THE COMPLETE PHOTO GUIDE TO
HAND LETTERING & CALLIGRAPHY

THE COMPLETE PHOTO GUIDE TO
HAND LETTERING
& CALLIGRAPHY

THE ESSENTIAL REFERENCE FOR
NOVICE AND EXPERT LETTERERS
AND CALLIGRAPHERS

ABBEY SY

Creative Publishing
international

Brimming with creative inspiration, how-to projects, and useful information to enrich your everyday life, Quarto Knows is a favorite destination for those pursuing their interests and passions. Visit our site and dig deeper with our books into your area of interest: Quarto Creates, Quarto Cooks, Quarto Homes, Quarto Lives, Quarto Drives, Quarto Explores, Quarto Gifts, or Quarto Kids.

© 2018 Quarto Publishing Group USA Inc.

First published in 2018 by Creative Publishing international, an imprint of The Quarto Group, 401 Second Avenue North, Suite 310, Minneapolis, MN 55401, USA. T (612) 344-8100 F (612) 344-8692 QuartoKnows.com

Creative Publishing international titles are also available at discount for retail, wholesale, promotional, and bulk purchase. For details, contact the Special Sales Manager by email at specialsales@quarto.com or by mail at The Quarto Group, Attn: Special Sales Manager, 401 Second Avenue North, Suite 310, Minneapolis, MN 55401, USA.

10 9 8 7 6 5 4 3 2 1

ISBN: 978-1-58923-963-0

Digital edition published in 2018

Library of Congress Cataloging-in-Publication Data available

Design and Page layout: Laura McFadden Design, Inc.
Cover Image: Abbey Sy
Photography: Abbey Sy; except page 189 by Ber Garcia.

Printed in China

Dedicated to
the artist in all of us.

Contents

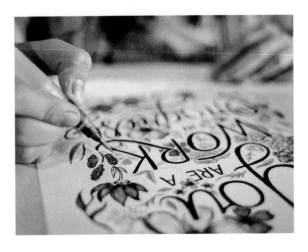

PREFACE

Letters communicate effectively through words and the stories they tell; but they also have a visual component, that adds meaning through illustration and other decorative effects. The recent resurgence of calligraphy and hand lettering has given artists and designers new and classical techniques to incorporate into their creative work, paving the way for the craft to flourish in the years to come.

The Complete Photo Guide to Hand Lettering and Calligraphy takes you through the process of turning letters into art, and it demonstrates various ways you can use calligraphy and hand lettering in your artistic practice. Whether it's designing an invitation, writing a heartfelt note to a friend, creating your own gift wrap, or decorating a tote bag, this book shares a multitude of ways to get creative with your letters and layouts.

You will find information about the range of traditional, modern, and digital tools; a lettering primer featuring alphabet characteristics and techniques; a guide to classical calligraphy including italics, copperplate, Spencerian, blackletter, and roman; a chapter on modern hand lettering and using different types of scripts, flourishes, and flowers to embellish your work; an in-depth look at decorative lettering and composing layouts; and last, an introduction to digital lettering and how to transform hand-drawn elements into digitally rendered illustrations.

Whether you're just starting out or deep into the world of calligraphy and hand lettering, I hope you find this book to be a useful and inspiring tool for your creative endeavors. There is always something new to learn.

Always be creating,

HOW TO USE THIS BOOK

This book is a thorough guide to the world of calligraphy and hand lettering. Here are some tips on how to use this book.

1 Read and take notes.
Each chapter contains how-tos on different kinds of calligraphy and hand lettering. Take notes and keep in mind some techniques you can use for your work. You can use this book as a launching point for further research once you discover which type of lettering you want to focus on.

2 Familiarize yourself with the terminology.
You will encounter many typography-related terms in the following pages. Familiarize yourself with the commonly used terms, most of which are defined in the text or in the glossary (see page 183).

3 Use practice sheets for application of skills and monitoring your progress.
At the end of this book, you will find 32 pages of practice sheets for you to apply what you've learned and to track your hand-lettering and calligraphy process. Each chapter has a corresponding set of worksheets so you can do your drills as you make your way through the book.

4 Experiment and have fun.
Whether it's working on your strokes and drills for calligraphy, thinking of patterns to apply to your letterforms, or starting your own DIY project, experiment and have fun. Enjoy the process of learning new skills and honing your creative juices.

Time to turn the page and start creating!

Tools and Materials

Tools are important parts of the creative process. Traditional and modern tools each create a different impact on the final piece of art. Each artist has her own preferences and needs, but it is best to experiment with a variety of techniques and tools to learn how you can incorporate new methods and materials into your work.

This chapter explains the various kinds of materials you will encounter as you try your hand at calligraphy and lettering, highlighting their distinct qualities, where to find them, and which types best fit each area of calligraphy or hand lettering.

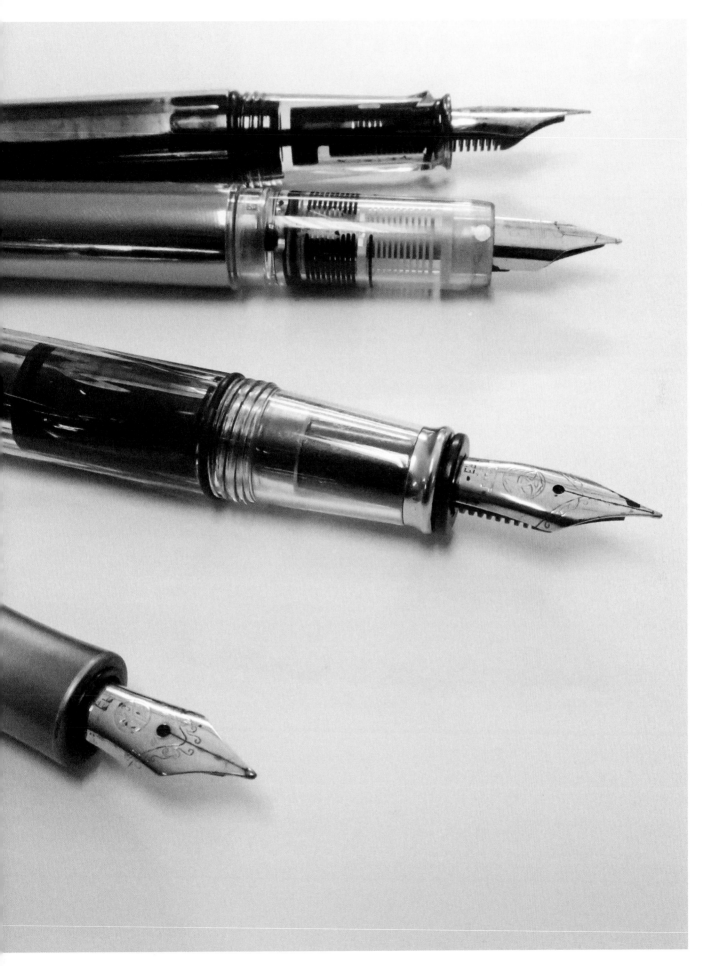

Traditional Tools

Nibs

Nibs come in two styles: pointed and italic. Each type has a specific set of qualities that suit different calligraphic styles.

Pointed nibs are flexible and can be used for most calligraphy styles, as they have the versatility to produce both thick and thin strokes. The nibs two tines have the ability to split and produce wide lines. When the tines are together, they produce a thin stroke.

Italic, or broad-edged, nibs are flat and not designed to flex. These are used for italic, black letter, and gothic letterforms. This nib type is used to create consistent and uniform strokes. Its blunt edge creates strokes that are thin or bold.

Flat-Tip Dip Pens

Flat-tip dip pens are commonly used for black letter, italic, and other hands. Although the parallel pen is available, there are still those of us that favors this tool. Flat-tip dip pens have two parts: the nib and the holder. There are various types of flat-tip nibs that come in different cuts and sizes. These pens have stiff nibs and thus a low flex level.

Although this pen produces a very engaging and alluring contrast between the thin and thick strokes, it still requires more skill and practice to keep lines in place. Another good thing about this pen is that you have more options when choosing nibs, inks, and even holders. For ink loading, it is best to use a paintbrush and add ink on it rather than dipping the nib directly to the bottle of ink. This ensures minimal disruption and lets you control the amount of ink on the nib.

Nib Holders

Nib holders come in both straight and oblique styles. Each type has distinct characteristics and its use depends on calligraphy style and the artist's preference.

Straight Nib Holder

The straight holder is generally easy to control and is good for beginners because the orientation is similar to a pencil or pen. It is also recommended for left-handed writers as it is easier to adjust the angle of the nib and pen to paper to accommodate their writing. Although it is more common now to see straight holders used for broad-edged writing, they are also used for scripts and flourishing. Using the straight holder gives a modern and straight effect to your work because, unless you deliberately angle your paper, your writing will be upright.

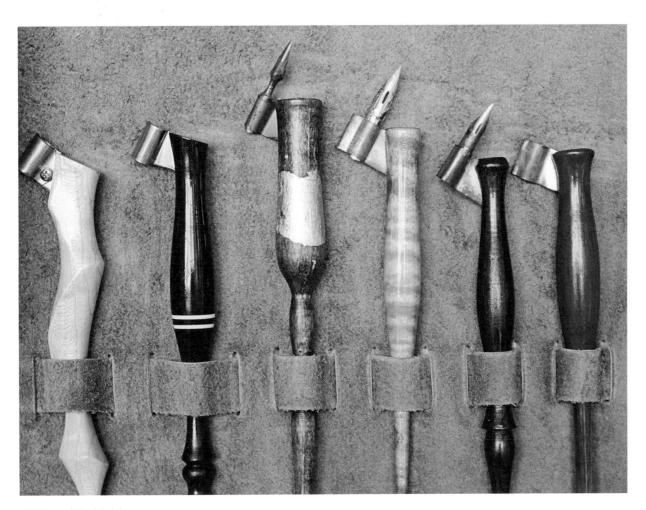

Oblique Nib Holder

The oblique pen holder gives an automatic slanted effect to your letters and flourishes, making it great for practicing formal styles such as Spencerian and copperplate calligraphy. Oblique holders allow the writer to achieve a specific angle, which helps to form consistently slanted forms.

Inks

Calligraphy inks come in a variety of colors—from the commonly used black ink, to metallic, and many types of colors. They are also made of different transparencies, but most inks appear opaque. Inks can be thick or thin, which creates a variety of effects on paper.

Depending on the style of letters you want to achieve, your ink choice will differ. A carbon-based ink such as sumi is useful for the beginner, as it can be diluted with water to adjust flow. India and acrylic inks are also widely used because of their opacity and vivid colors. Gouache may also be mixed to make a wider selection of colors. Other inks coveted for their fine lines and superb flow would be walnut, which has a brown/sepia color, and iron gall, which is a lightly hued ink that will darken over time. For decorative and fancier effects, calligraphers can also use acrylic or water color inks with mica or metallic particles for an extra shimmer.

India Ink

The preferred ink for beginners, india ink is pigment based and waterproof. It comes in a variety of colors.

Sumi Ink

Sumi ink is a black, carbon-based, waterproof ink. It dries more matte than india ink, and is the ideal choice for most calligraphers. Thickness and flow can be adjusted by adding a bit of water.

Dye-Based Ink

Dye-based ink is used for both fountain pens and dip pens. Since these are watery in consistency, the written output on paper appears translucent and can have a lighter effect.

White Ink

For calligraphy on black paper or other surfaces, white ink is a good choice as it pops out on the paper. Bleed-proof white ink is recommended, as it is opaque and intermixable.

Colored Ink

Ready-made colored calligraphy inks are readily available at art supply stores. Not all of these are waterproof, though, so read the label carefully when choosing an ink for mixed media art. Non-waterproof ink is fine for line art or calligraphy. Consistency may vary depending on the base of the inks (if it is made of acrylic, gouache, or natural dye), so flow and quality of lines will vary, too.

You can also make your own acrylic-based colored ink by mixing acrylic paint and water in an airtight jar. The quality will be more transparent and watercolorlike compared to ready-made ones, but it is highly customizable. Gouache is also a popular choice for mixing your own inks because of its easy flow, but you will need to add a bit of gum arabic to keep the pigments together and the color more opaque.

Metallic Watercolors

To create sparkling calligraphy, use metallic watercolors. The watercolors are made with a natural shimmering mineral, making it sparkly when applied to paper. Load the pigment onto a brush, as if it were paint, and then transfer it onto your nib.

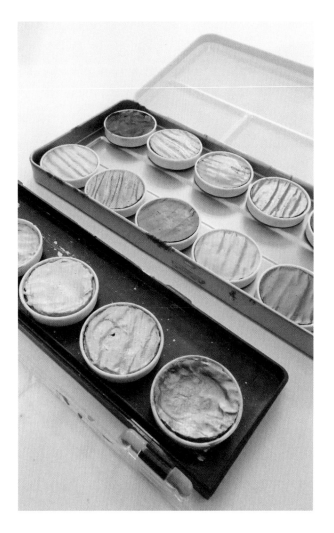

Fountain Pens

A convenient alternative to dip pens are fountain pens. Fountain pens store ink in cartridges that are easily refillable once they run out.

A big difference between a fountain pen and the dip pen is its flexibility. Fountain pen nibs tend to be less flexible, therefore resulting is less stroke contrast. Not all fountain pens are designed to flex, so be sure to check whether the pen is flexible before applying pressure.

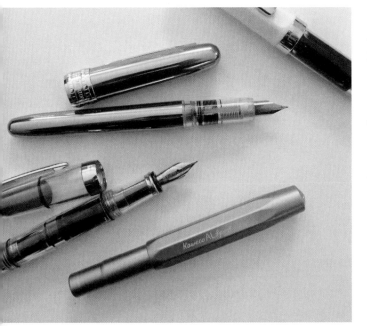

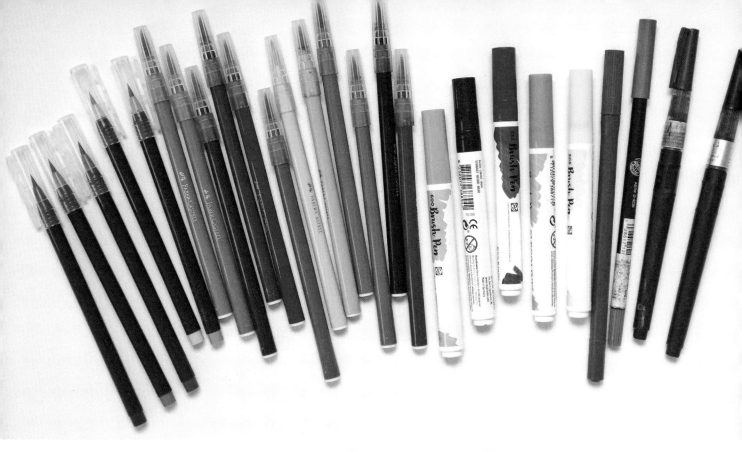

Modern Tools

Brush Pens

A flexible, convenient update to the brush, the brush pen allows the calligrapher to create fine, medium, or broad strokes. Brush pens come in a variety of tip sizes and types.

Felt-tip brush pens are similar to markers, only with a brush tip. This pen is easy to use because the tip springs back to its original shape after writing. The pens come in a variety of colors, making it perfect for beginners who are interested in trying brush lettering.

Natural hair brush pens are ink based. With its smooth ink flow, a natural hair brush pen can create both thick and thin brushlike strokes, perfect for loose and freehand brush lettering.

Synthetic hair brush pens are water based. The ink flow is smooth and consistent, and the tip feels like a soft brush. Colors blend like watercolors, making it suitable for gradient-style brush lettering.

Fineliner/Drawing Pens

Fineliner pens are similar to a ball-point pen. Although its round tip is suitable for most forms of lettering, it is best to use for hand lettering.

Fineliners come in different points, from the thinnest at 0.05 mm to the thickest at 1.0 mm. Thin pens are used for meticulous details, intricate patterns, and inlines; and thick pens are used for bold/graphic outlines, shadows, and filling in areas.

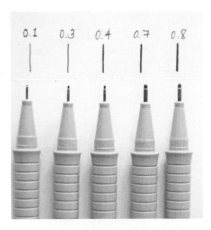

Markers

Markers are round-tip pens that create thick, bold lines. They are great for block letters or illustrations that require a big canvas. Markers can be waterproof or permanent, depending on ink qualities. Most come in an extensive range of colors for doodling and drawing, and some types have chiseled tips for varied width.

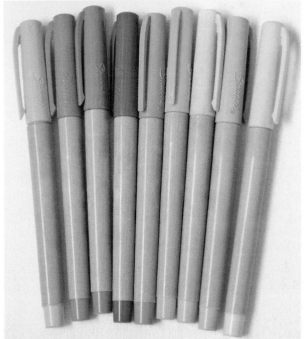

Chalk

Chalk comes in two types: regular chalk and chalk markers. Both can be used on chalkboards, but they have different effects.

Regular chalk usually comes in a box. This is best for practicing as it is inexpensive and erases easily.

Chalk markers come in pen form, with opaque liquid ink stored inside the body. Apart from chalkboards, chalk markers can also be used on glass or metal surfaces.

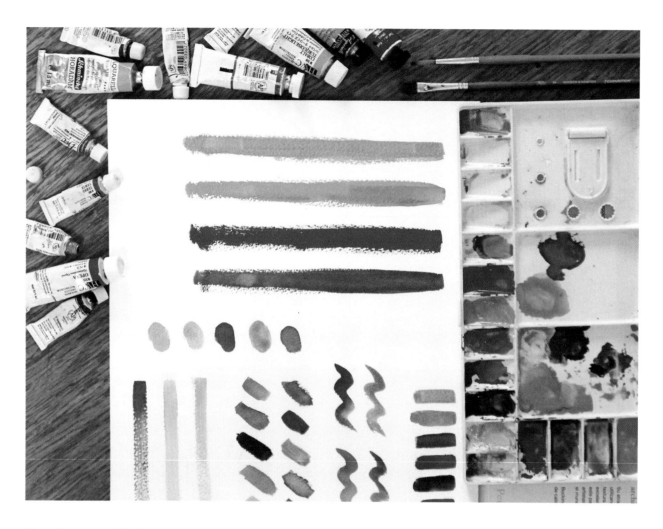

Brushes and Paints

Brushes used for hand lettering come in different types. Synthetic brushes (made from nylon or taklon) are useful for brush lettering, as the bristles don't separate when used. They also don't hold a huge amount of water. This helps create strokes for gradients and bouncy lettering. Animal hair brushes (made from sable or kolinsky, which is a kind of weasel) are soft and mostly used for washes and achieving a watery effect to your hand lettering.

Round, flat, and liner brushes are the commonly used tips of brushes. A round brush is versatile and is usually the first choice for painting letters, as it creates a range of thick and thin strokes. A flat brush creates a more dimensional effect to letterforms, and is mostly used for roman or gothic lettering. Liner brushes are great for inlines, outlines, and areas where superfine details are needed.

Brushes can be as thin as #000 or as thick as #10. Make sure to have a selection of at least three numbered brushes to use for a variety of letter styles.

Paints used for hand lettering usually range from watercolors, gouache, to concentrated watercolor ink. The best part about using watercolors is you can create and combine your own set of colors with your palette.

Whether your watercolors are student or artist grade, it's important to choose which colors to put into your arsenal of paints. Most watercolor packs come in the basic primary colors, while others can be customized and combined. Watercolors are activated once water is mixed with the pigment, and its opacity can vary depending on the amount of water and paint combined in the mixture. Naturally, watercolors are transparent when applied to paper, creating a watery effect.

Gouache is an opaque form of watercolor paint. It's more pigmented and is usually used when several colors are needed for a certain letterform. Its opacity enables the colors to pop individually on paper, which is great if you're aiming to achieve a sign-painter style of lettering work.

Concentrated watercolors are already mixed and come in a bottle. Because it is highly concentrated, this type of watercolor is best for gradients and artwork that requires vibrant and bold colors.

Colored Pencils

Colored pencils are a commonly used art medium for coloring and illustrating, as they create rich and vibrant hues when applied to paper. The strokes produce an organic effect to your work. Watercolor pencils are similar but are water-soluble and suitable for painting your letters.

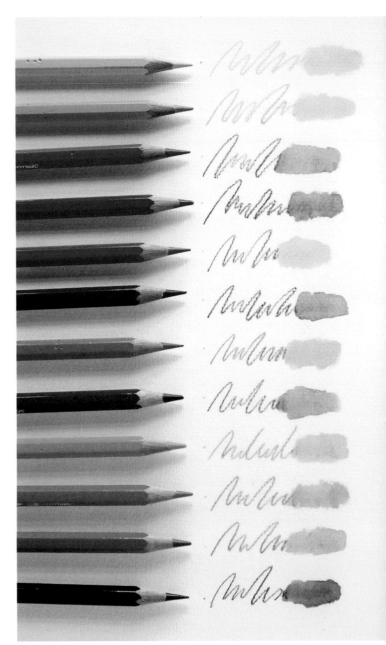

Digital Tools

Desktop Computer or Laptop

Depending on each person's work preferences, either a desktop computer or laptop is an essential tool for digital lettering. Most artists and designers prefer desktop computers with large screen sizes for an optimal workflow; but for those on-the-go, a durable laptop always comes in handy.

Adobe Photoshop/Adobe Illustrator

Both of these Adobe programs are suitable for digital lettering, depending on the technique(s) implemented and preferred. When editing photos and adding lettering, Photoshop comes in handy; but for illustrating letters and creating decorative elements, Illustrator is the best option.

Scanner

A scanner is commonly used for artwork that is traditionally illustrated and then rendered digitally. It's also easier to manipulate the scan of the artwork as the resolution (which is in dots per inch or dpi) can be edited. The ideal scanned size should be at least 300 dpi for a good resolution.

If only a low-resolution file is needed for scanning, most smartphones have scanner applications that can be used for the same purpose.

Tablet

A tablet is the best alternative to a mouse when illustrating digital letterforms. The pen simulates a tangible tool, and the output is shown on the computer screen—making it easy to transition from traditional to digital lettering.

Others Tools for Lettering

Some of the basic tools that are needed for lettering include the following:

Lead Pencil
Depending on the hardness of its lead, pencils are great for both tracing and/or shading. HB is the default hardness and it ranges from H to B. H tips are lighter and harder, but B tips are darker and softer. Pencils are often used for initial sketching of layout designs.

Mechanical Pencil
Another option is to use a mechanical pencil. Mechanical pencils also have leads in red or blue, which are useful for line art drawing.

Eraser
Keeping an eraser on hand is important, especially when using pencils for sketching and drawing letterforms.

Sharpener
Sharpeners are useful for keeping both pencils and colored pencils sharp.

Ruler
For precise measurements, it's necessary to have a ruler in either 12" or 6" (30 or 15 cm) dimensions, depending on the paper and layout size.

Compass
Mostly used for circular layouts, a compass is also useful for illustrating circles and round objects for hand lettering.

Cup and Palette
Both cup and palette are important for watercolor work. The cup is for water storage while the palette is for color mixing using paint tubes and pans.

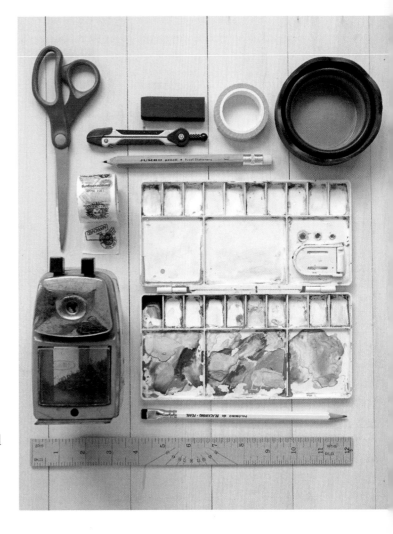

Scissors
Scissors are used to cut paper or other surfaces to size for hand lettering.

Washi Tape
Useful for drawing or painting, washi tape is more durable than masking tape and works well for holding paper in place on the desk and preventing crumpling.

Surfaces

Paper

Papers come in different textures, sizes, and weights. Here are some of the common terms when it comes to paper:

Tooth

Tooth is the surface feel of paper. The more tooth a paper has, the rougher it feels. There are different types of paper textures, but the most common ones are hot-pressed and cold-pressed paper.

Hot-pressed paper is very smooth—similar to the effect when paper is ironed out with heat. Cold-pressed paper is a bit rough, and more suitable if you're keen on adding more depth to your work. Both are used for watercolors, and you can choose what kind of effect you want to achieve.

Weight

The weight of paper is measured by grams per square meter (gsm). The higher the gsm a paper has, the heavier it is. It is best to use at least 60–70 gsm paper for practicing lettering or calligraphy. For special work, such as addressing invitations or formal occassions, the paper should be at least 200 gsm.

Size and Dimensions

Paper size is an important consideration for calligraphy or hand lettering. A default preference is using letter size (8.5" x 11" or A4) or half-letter size (8.5" x 5.5" or A5), as they are both commonly available. When doing framed artworks, it's best to use a larger size such as legal size (11" x 17" or A3) or 17" x 22" (A2). It is advisable to use sizes that are a bit larger than required so it will be easier to trim off the edges once it's ready.

Hot-press (smooth) and cold-press (rough) papers

Other Surfaces

Although most lettering work is done on paper, there are surfaces that can be used as an alternative and are equally great for lettering.

Surface: Wood (plywood or any light-colored wood)
Tools: Paint or permanent markers

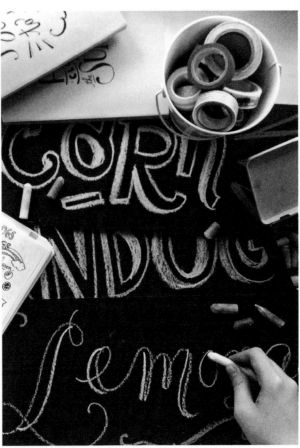

Surface: Chalkboard
Tools: Regular chalk or chalk marker

Surface: Glass
Tools: Chalk marker (temporary) or glass marker (permanent)

Surface: Canvas cloth
Tools: Acrylic paint, permanent markers, or fabric markers/pens

Lettering
Primer

What is a typeface? What is the difference between hand lettering and calligraphy? How do you start to draw letters? In this chapter, all of your questions about the basic concepts that make up the foundation of all lettering and the associated terminology will be answered. You'll discover the variety of letter styles that will be introduced in this book, alphabet characteristics, methods for adding weight and connecting letterforms, and the very first steps you need to know for proper letter formation.

Anatomy Lesson

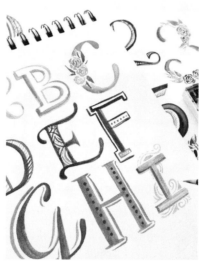

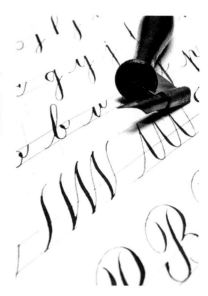

Typography

Typography is the art of putting together various typefaces in order to create a work of art. The earliest form of typography was blackletter, the first-ever typeface developed by Johannes Gutenberg, the inventor of the movable-type printing press. As the digital era came along, designers incorporated typefaces into their work. This lead to the emergence of font styles to suit any taste.

Hand Lettering

Hand lettering is the art of drawing letters based on draftsmanship for a specific purpose. Hand lettering can be rendered using a variety of tools such as pens, pencils, markers, brush pens, brushes, and paint to create an illustrated medium.

Calligraphy

Calligraphy is the art of writing letters based on handwriting. It involves the correct formation of characters, the ordering of letter parts, and the harmony of proportions. Calligraphy can be rendered using a pointed pen with different nib types and ink, as well as fountain pens and parallel pens. Traditional calligraphy is composed of various types: Spencerian, classical, roman, blackletter, and italic. In recent times, it has modernized into brush lettering and other similar forms.

Uppercase

ABCDEFGHIJKL
MNOPQRSTUVWXYZ

Lowercase

abcdefghijklmn
opqrstuvwxyz

Basic Terminology

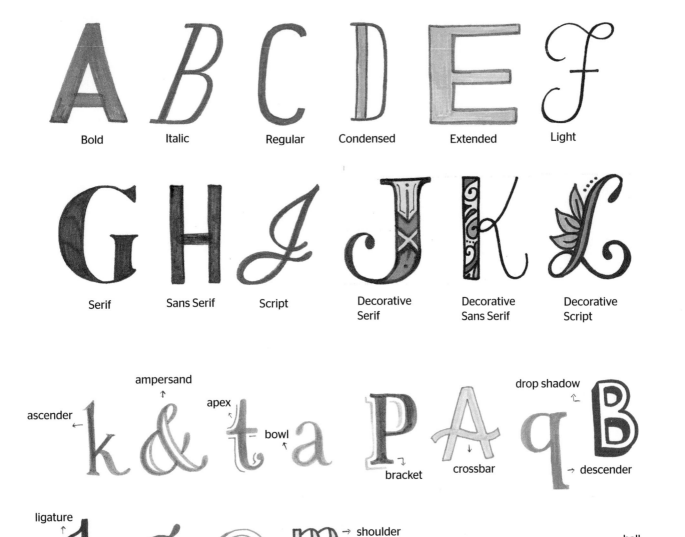

Bold Italic Regular Condensed Extended Light

Serif Sans Serif Script Decorative Serif Decorative Sans Serif Decorative Script

ascender • ampersand • apex • bowl • bracket • crossbar • drop shadow • descender

ligature • love • inline • outline • stem • shoulder • spine • swash • ball terminal • tail

Typeface: the letters, numbers, and symbols that make up a design of type

Kerning: the space between characters

Leading: the space between each line of type

Tracking: the amount of space between letters in a word

Squoosh: the process of squashing or expanding words so they can fit in a layout

Framework and Structure

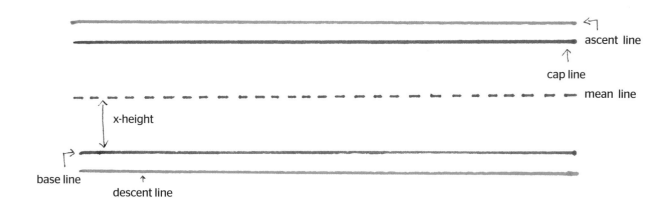

ascent line

cap line

mean line

x-height

base line

descent line

Featured Styles

Below are the styles of classic calligraphy shown in this book (see pages 32-77); some of the modern styles (see pages 78-109) are shown on the previous page.

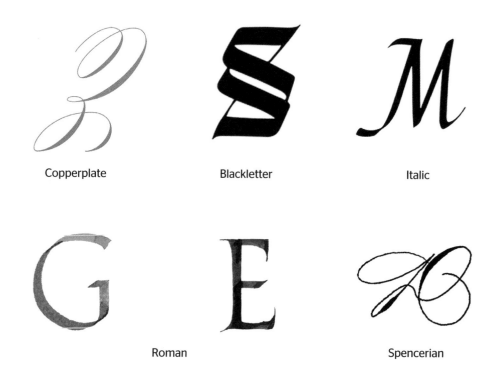

Copperplate

Blackletter

Italic

Roman

Spencerian

Forming Letters

Letters are made of shapes and strokes; and in both calligraphy and hand lettering, combining these two can form letters in a pleasing manner. Most letters are composed of similar shapes and strokes. Our own handwriting is the primary basis of how we form letters, which is why practicing handwriting is also key to becoming proficient at calligraphy and hand lettering.

Hand lettering focuses on drawing letters, so it's important to play around with different heights and widths in order to achieve a variety of styles. By constantly experimenting, you can create several outputs that can eventually help you hone your personal lettering style. Keep practicing and you will improve over time.

Forming letters are different for print (or block) letters and cursive letters, as these have distinct qualities to their respective styles. Here are some tips to remember when forming letters.

Cursive Letters

1. Start by doing warm-ups of various strokes—upstrokes, loops, and downstrokes are the most common. This helps your hand get accustomed to your pen.

2. When you write, lift your pen between strokes, as it becomes easier to follow through with the strokes.

3. You have the option to alter strokes to your preference. The stroke can vary depending on whether your cursive is straight or italic.

4. Remember, upstrokes require light pressure, and downstrokes require heavy pressure. Keep alternating both strokes and you'll eventually get the hang of it.

Printed/Block Letters

1. Start practicing with your handwriting: write letters in different shapes, heights, and widths on paper.

2. From there, analyze the shapes comprising each letter. This should give you an idea of how each letter is formed.

3. Enhance each letter by either thickening some areas or altering the form to achieve a specific style.

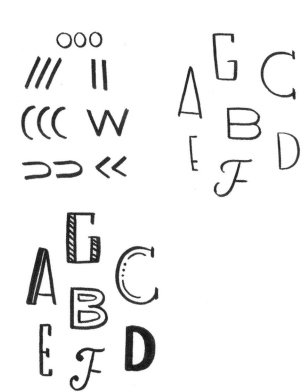

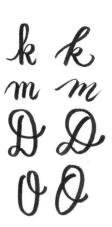

Adding Weight Lines

Our eyes are very receptive to seeing differences in font styles, especially when size is reduced or, in this case, when certain typefaces are thicker. In typography, adding weight lines to words in a body of text implies that it has a message that needs to be highlighted. In the same way, applying this technique to hand lettering is an indicator of importance of a specific bold set of words or sentences.

This is commonly termed as a bold font style, and is darker and heavier than other font styles. Bold type was introduced in the mid-nineteenth century. The first widely used bold typefaces were initially used for announcements or advertisements, which means they were often large as well as bold. Eventually, bold style was adapted to body text.

Bold fonts are used for headlines, announcements, and big signs, as size and weight is a way of ranking of information. In hand lettering, bold lettering is applied to words that the artist wants to stand out. Typically, in a quote layout, only one or two words are emphasized by large or bold font. These words can serve as the key points or main theme of the quote.

Apart from adding weight lines, outlines and shadows are also supplementary techniques that can be applied to letters in order to create dimensional and decorative effects.

Connecting Letterforms

A ligature occurs when two or more letters are joined together to form a single character. Typographical ligatures originated when businesspeople needed to speed up their writing process in order to communicate more quickly. Joining letters and abbreviating certain words made writing records and transactions more efficient. Accordingly, older style typefaces have ligatures as part of their font library.

In hand lettering, ligatures are applied to certain letter combinations to make type look more attractive. Joining two or more characters together can make letters look more cohesive. This is a common technique applied to logos or one-word statements. In a layout, connecting letterforms can also create harmony between letters and, sometimes, even a combination of words.

Did you know the ampersand (&) was actually developed from a ligature of letters e and t ("et" is Latin for "and")?

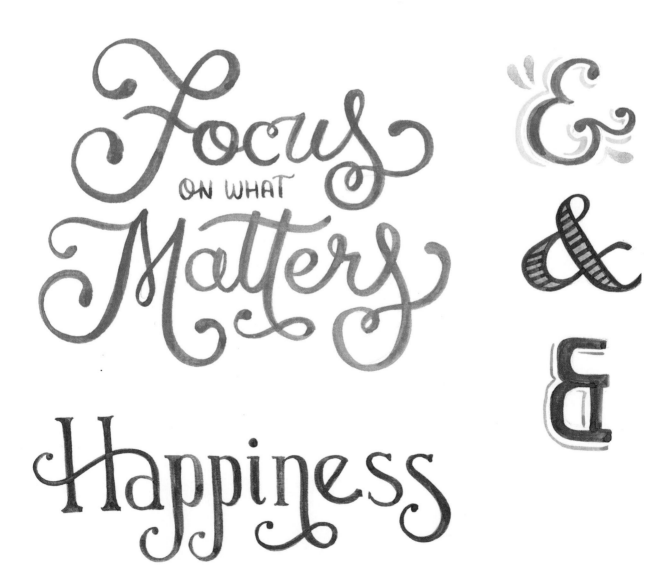

Classic Calligraphy

by Fozzy Castro-Dayrit

Writing systems are influenced by the events and values of the people they belong to, as well as the materials available at the time. For example, Spencerian script (with ornamental American penmanship) came about in the nineteenth century, when the United States needed a writing system that was rapid, legible, and yet graceful, to aid in the growth of commerce and industry.

The purpose of this chapter is to give you a glimpse of the richness of classic calligraphy, its tools, forms, and styles. The expressiveness of modern calligraphy comes from the discipline of the classic forms. Appreciation of the old writing systems will help the artist decide which rules to break in order to modernize their work.

As with anything, confidence and ease in your strokes and composition will grow with practice. Acquire the best tools you can afford and enjoy exploring.

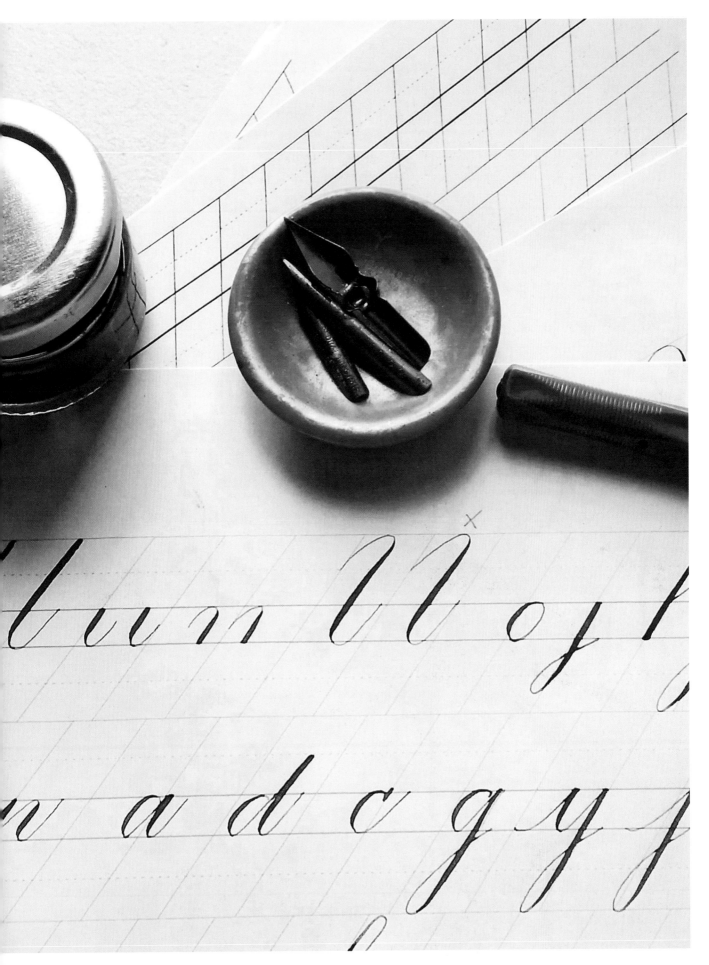

Using Traditional Tools
by Fozzy Castro-Dayrit

Before modern ink reservoirs, refills, and felt tips, artists had to assemble or carve their own pens and dip them in a bottle of ink. Whether you want to experience the sense of history that comes with using traditional tools or the convenience of more modern tools, it is important to have the best-quality materials you can afford. They don't have to be expensive, but they should be well made.

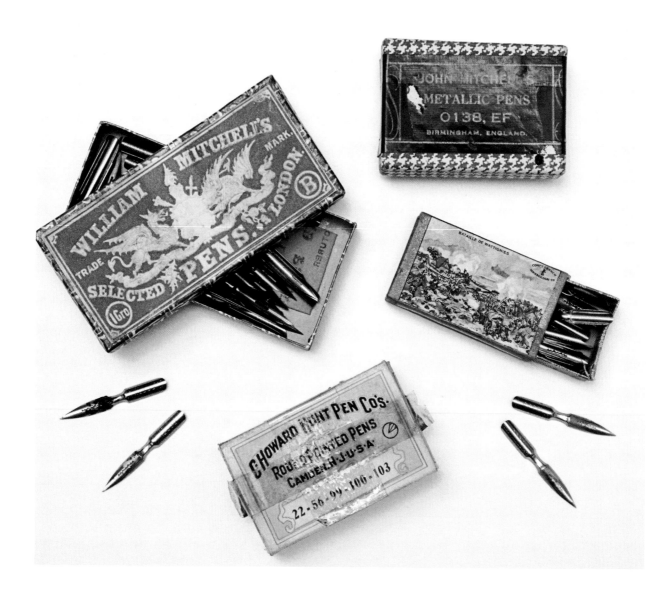

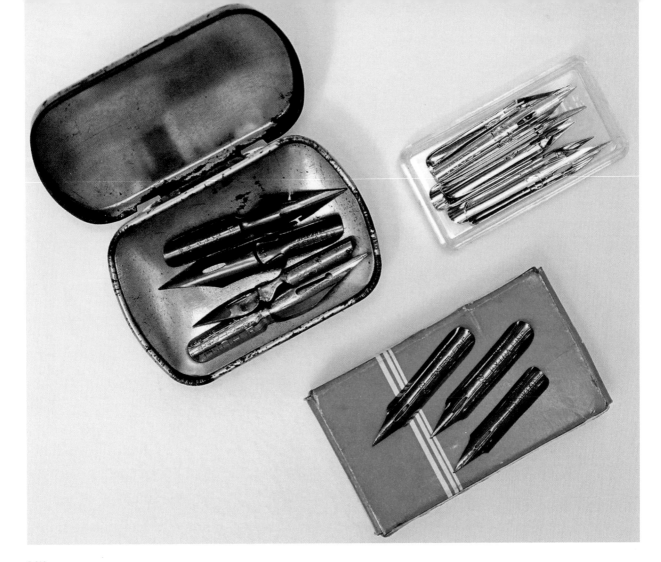

Nibs

Nibs are made out of thin metal sheets, usually steel, bronze, or titanium. They typically have two tines with a slit through the middle and a vent (a little hole) in the body or shank. Sometimes, the metal is folded, which creates a reservoir for the ink between the two sheets. They come in a variety of point styles.

The most common nib for calligraphy pens has a flat or chiseled tip. These are used for italic, gothic, black letter, and roman hand. Flat nibs have a bold, thick line, but can produce thin lines when the angle of the pen is changed.

Pointed and flexible nibs are used for scripts such as copperplate/engrosser's (also sometimes called English roundhand), Spencerian, and ornamental script. The tines on flexible nibs split apart when pressure is applied, which creates shaded strokes, and they snap back to a fine point when pressure is released.

There are a number of nibs available with varying flexibility. If you are a beginner, it may be better to start with a stiffer nib like the Japanese G nibs. Moving to softer or finer nibs can be done as you progress with your practice. Each nib and writer is different, so take your time and test them until you find one (or a few) that would work for you.

Always clean your points as you use them and before you put them away. Keep an eye on your nibs to make sure the tines are not misaligned or rusted. If this happens, it is best to replace the nib.

Store your new nibs separately from your old nibs, because rust spreads. You may use tin boxes or plastic organizers found in tool and hobby stores.

Pen Holders

There are two kinds of pen holders: straight and oblique. Holders can be made of plastic, acrylic, metal, or wood. Wooden ones are preferred by the traditional artist.

Straight holders are needed for styles involving the broad nib. They also are the best holder for lefties.

The oblique holder was developed to help the artist achieve a consistent slant to script letters. It can also be used for offhand flourishing. Choose an oblique holder with a metal flange, because it can hold almost any size nib. Although it was designed for right-handed people, left-handed obliques are available as well.

Ergonomic or comfort holders are hand carved with grooves that show the student where to place their fingers. In order to have the best design and fit, makers of such pens often encourage their customers to send photos and measurements of their hand.

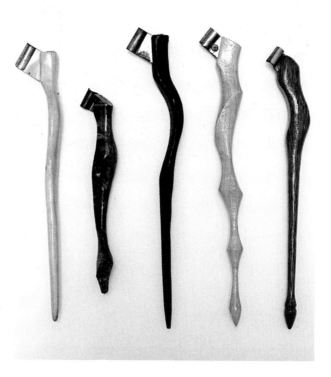

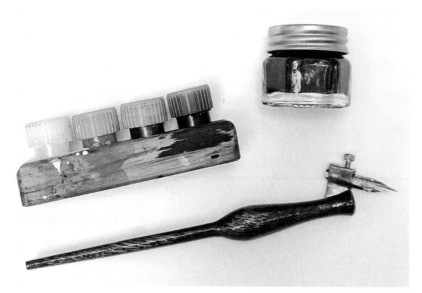

Ink

Traditionally, the nib or pen is dipped into a separate bottle of ink. Because there is no reservoir in the pen to hold the ink, the liquid must be viscous enough to hold on to the nib by itself without compromising its flow.

Inks comes in bottles of 3 oz and above. For ease of dipping as well as transport, they can be decanted to little plastic screwcap bottles called dinky dips. Little jam jars work as well.

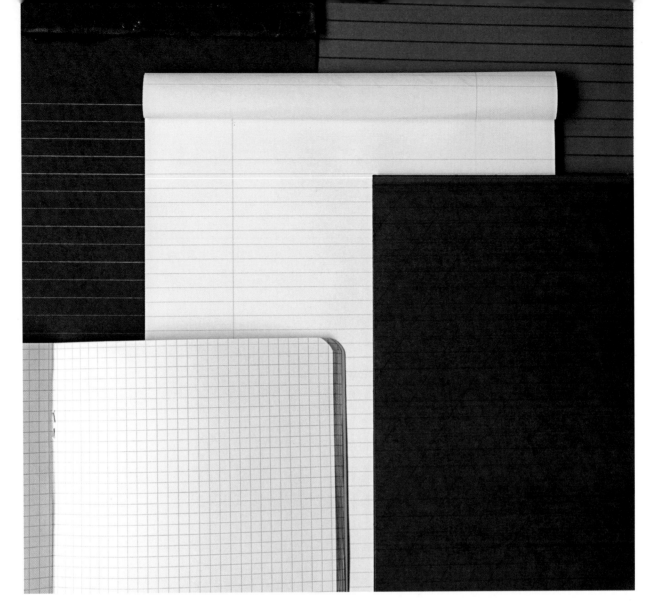

Paper

It is best to use paper of at least 80 gsm in weight that has a degree of smoothness and tightly woven fibers. If the surface is too glossy, the ink might bead or just sit on the page or the lines could appear thicker than intended. A bit of bite (or tooth) tends to produce crisper lines and helps with writing flow. Laid and watercolor (hot pressed) paper are good examples of this type of paper. If a pad or notebook is marked as suitable for fountain pen use, it is usually appropriate for calligraphers as well.

Colored paper and white ink is fun to use, as well, for both decoration and practice. Black paper with white ink is popular because it is very dramatic. The negative contrast also helps you see lines and spaces better.

TIP

Place a couple of pages on the table under your writing page to create a cushion for the nib, which will improve the ease of pen movement and ink flow.

Using Modern Tools

AJ Tabino

Modern and updated tools offer more opportunities for calligraphers to practice their art. Fountain pens are one of the most common pens for calligraphy-style script. They come in a wide variety of tips and styles. Another modern tool is the parallel pen. This broad-edged pen is excellent for black letter writing, and the thickness of the stroke changes with the angle of the pen.

The nib of the parallel pen is made up of two metal plates in parallel to each other, leaving very minimal space in between for ink flow. The pen uses cartridges and provides impressive ink flow without the mess.

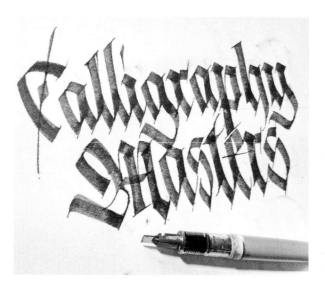
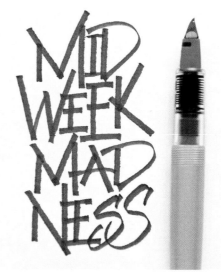

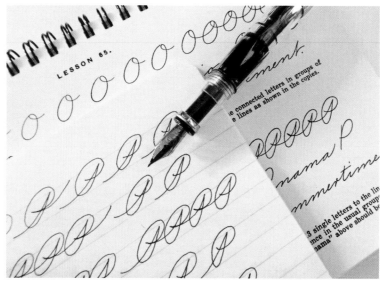

Getting Started

Before starting any project, you will need to prepare your workspace with your nibs, paper of choice, and inks. It is also key to have paper towels or a rag and a jar of water to clean your pen as you practice.

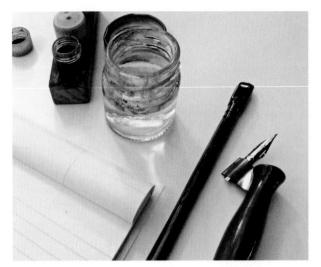

Next, your nib must be prepped. Remove any varnish or grease left on it during manufacturing, which will help the ink adhere and flow.

In order to prep your nib, scrub it lightly using a toothbrush and a mild cleanser (such as dish cleanser) or wipe it down with a paper towel and a cleaning solution containing ammonia (such as glass cleanser). Be sure to rinse with water and dry it thoroughly! Another method to prepare the nib is to pass it over a match flame 4 or 5 times. Dip the pen in water to cool it, then wipe dry. Do not try with a lighter or gas flame, as the intensity of the heat would damage the nib.

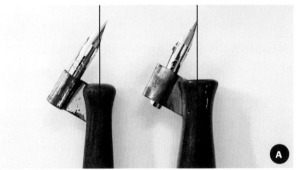

Now you can insert your prepped nib into your holder of choice. If you are using a pointed nib and an oblique, it is important to check that your nib point is aligned with your holder. The tip should be in line with the center of the holder (A). You may need round-nosed pliers to keep the nib in place while you adjust the angle. Position the pen with the nib pointing toward the top of the page. Always keep the midline of the pen aligned with the slant angle, especially for scripts (B). This will make the flow of strokes easier. Turn the paper to help align, if needed.

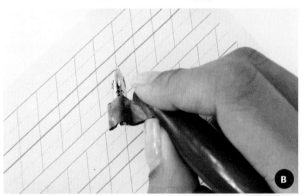

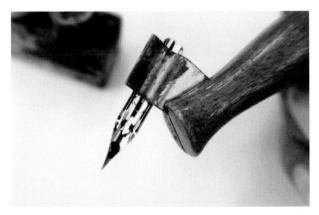

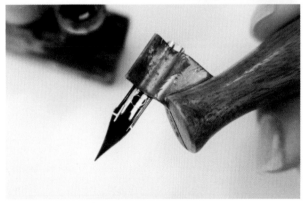

Compare: Ink will just sit and bead on a new nib (left), but a prepped nib will be thoroughly coated (right).

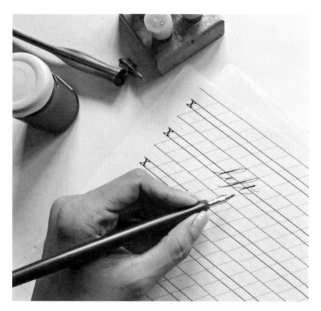
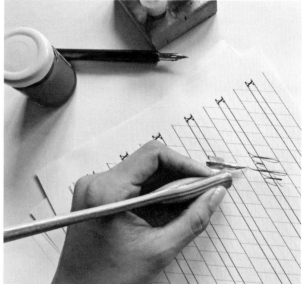

Left-handers should hold the pen so it approximates the angle of the letters. Turn the paper clockwise until comfortable.

Writing Posture

Make sure you are comfortably seated and your shoulders are relaxed. Rest your elbow at the edge of the table and hold your pen as lightly and naturally as possible. Keep a light grip in order to avoid stiffness and cramping.

If your hand feels awkward holding the pen aligned to the slant guides, rotate the paper counterclockwise until these two align. Some calligraphers write with the paper lines perpendicular to the body. Move the paper closer to you if you notice that you are stretching over the page. Adjust your tools and materials so they work with you.

Hold the pen so that it approximates the angle of the letters. Turn the paper clockwise until comfortable.

As you write, clean your nib to keep the ink flowing well. The pen, when left idle with ink, can get clogged. Dip the pen into that little jar of water and wipe it down with your paper towel or rag.

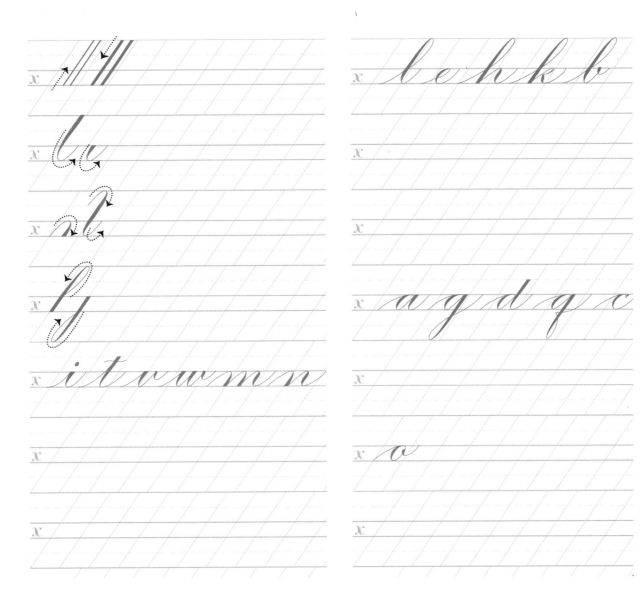

Upstrokes and Downstrokes

Form your upstrokes away from your body, exerting little to no pressure on the nib in order to make a fine line. The downstrokes are made by pulling the nib toward the body while applying pressure on the nib. This will make the tines split and will create a bold, swelled line. In Spencerian script, only select downstrokes have swells.

Make sure you have enough ink to complete a stroke. If you run out of ink in the middle of a downstroke, the split tines create tracks. This is called railroading.

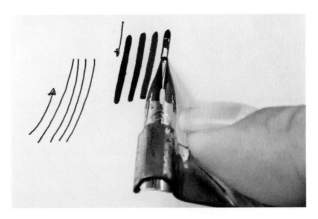

Apply pressure on the nib on the downstrokes to split the tines.

Italic Calligraphy

by AJ Tabino

Italic, also called chancery italic or cursive, is an accessible way to start learning calligraphy. The elegant letterform of italic makes it one of the most beloved styles of writing. Although a family of scripts, italic is usually characterized by forward slopes—slanting to the right, springing arches, and dynamic style.

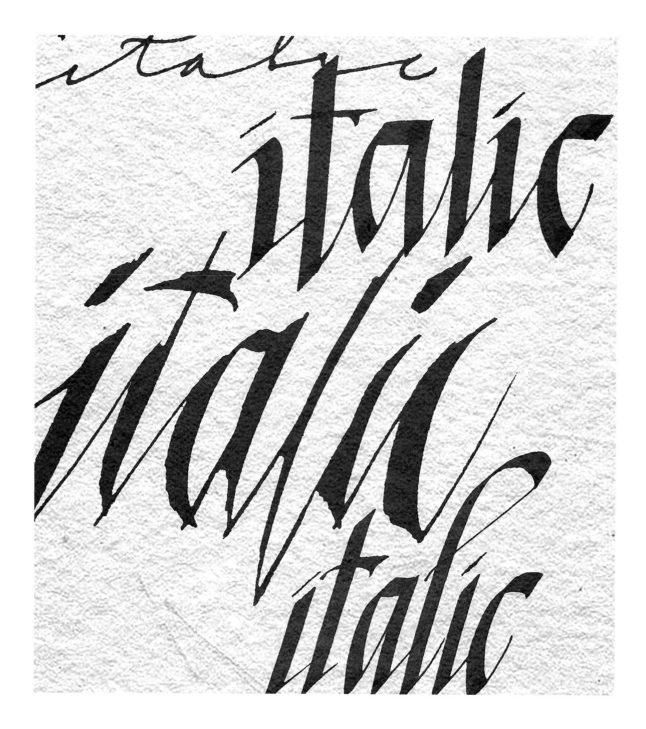

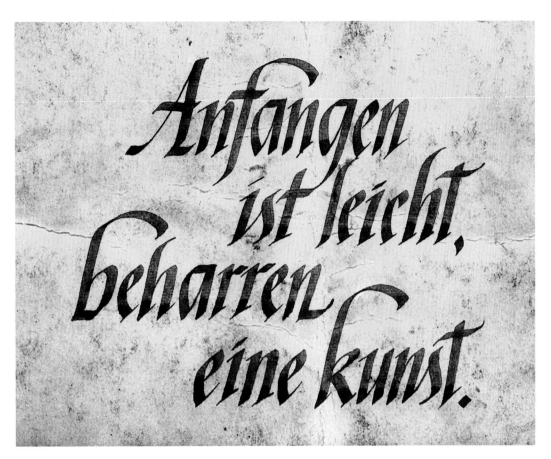

First used by clerks in the Pope's office, italic was developed during the Renaissance. Over the years, however, the italic hand became refined further for legibility and speed. The style evolved into different forms, becoming less angular and a bit rounder. Italic was popular throughout the sixteenth century and onward until the rise of copperplate during the eighteenth century.

Getting Started

To help you get started, here are the things you need to take note of.

Guide Preparation

First, create nib widths to serve as a guide for the size and position of your letters. To make a nib width, use your flat tip pen to create a square. You can also create them digitally. We will be setting the nib width ratio for italic at 3:5:3. This means three nib-widths for ascenders, five nib widths for x-heights, and three nib widths for descenders. Although various guides can be done with this hand, this is the one that works best for the pen that we will be using. Set the slope at 5° to achieve italic's slanted style.

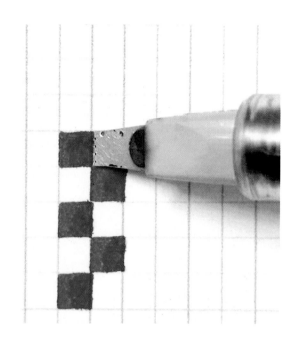

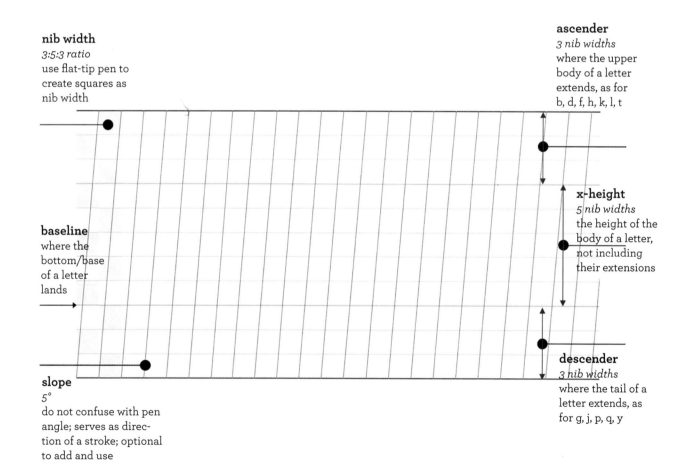

nib width
3:5:3 ratio
use flat-tip pen to
create squares as
nib width

ascender
3 nib widths
where the upper
body of a letter
extends, as for
b, d, f, h, k, l, t

x-height
5 nib widths
the height of the
body of a letter,
not including
their extensions

baseline
where the
bottom/base
of a letter
lands

descender
3 nib widths
where the tail of a
letter extends, as
for g, j, p, q, y

slope
5°
do not confuse with pen
angle; serves as direc-
tion of a stroke; optional
to add and use

Pen Angle

Pen angle is different from the letter slope. The slopes determine the direction of the letters, and the angle determines the contrast between thin and thick strokes. Usually, the pen angle for italic is between 30 and 45 degrees. To begin, we will use the 40-degree angle to highlight the distinct variation between italic and black letter.

Letter Variation

Italic is well known for the slants or slopes of its letterforms. However, italic is also a family of styles. The letters you see below are variations that show how positioning your pen can make a difference. The more you practice your italic hand, the more you will learn about how these letters are formed.

Try using different kinds of ratio for your guide. The differences that you will see will be more evident, depending on how high you set the x-height, ascender, or descender. Once you master the letterforms, you will see how fun it is to create variations. In addition to using different ratio for your guides, challenge yourself and use different sizes of pen. Experimenting is a great way to familiarize yourself with the letters and style.

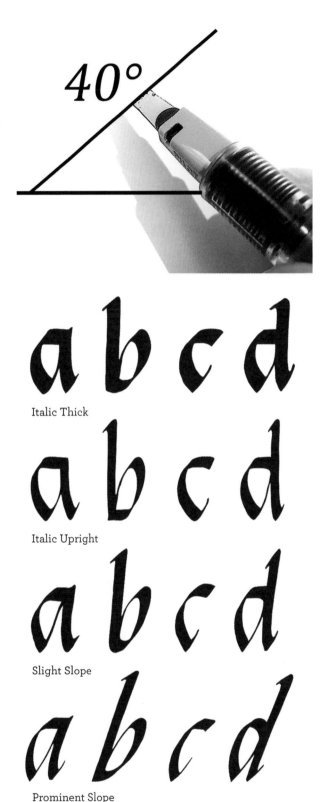

Italic Thick

Italic Upright

Slight Slope

Prominent Slope

Basic Strokes and Concepts

Italic alphabets have branching characteristics that makes it necessary for the pen to be adjusted as you write. See the guide, below, for the following basic strokes.

When creating these basic strokes, make sure you hold the pen firmly, but not so tight that you will cramp up. Make sure your angles are still on point, even when shifting to another stroke. Press, relax, and pull.

It is best if you complete a couple of basic strokes and drills before you proceed to writing letters. This helps you develop your muscle memory.

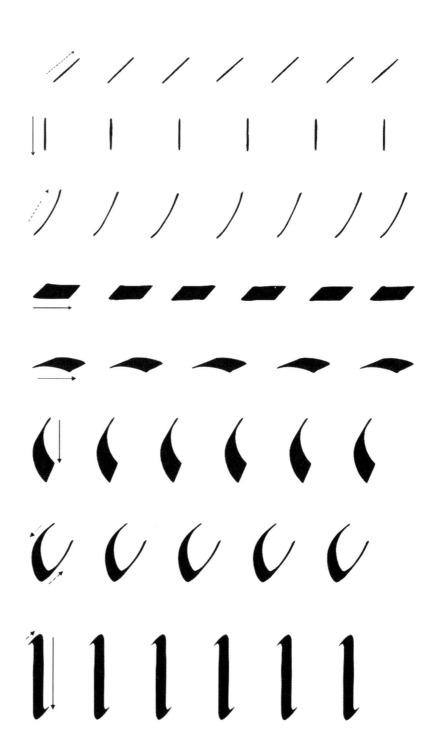

Thin Upstroke
Position your pen in an upright manner, then drag it going up

Thin Downstroke
Position your pen in an upright manner, then drag going down

Thin Curve Upstroke
Use an edge of a flat tip pen, go up and create a slight curve

Side/Dash Stroke
Drag the pen across the paper to the right; this is usually for letters f, t, z

Half Overturn
Start with a very thin upstroke, then an abrupt, thick downstroke (no lifting from the paper)

Crescent Stroke
Thin downstroke first, without lifting the pen off the paper; slightly add pressure going down to the right

Halfway Crescent
Start with a crescent stroke, then continue doing a thin curve upstroke

Upright Stroke
Maintain pen angle, slightly launch your stroke by doing a thin upstroke; maintain pen angle, then go down and abruptly end it with a very short, thin curved upstroke

Letter Structure

Once you've begun learning the basic strokes, you can start creating letters. Basic strokes serves as the foundation for any calligraphy letter, so always keep them in mind. If you have difficulty with a letter, go back and practice the strokes. Here are italic uppercase letters with their lowercase counterparts.

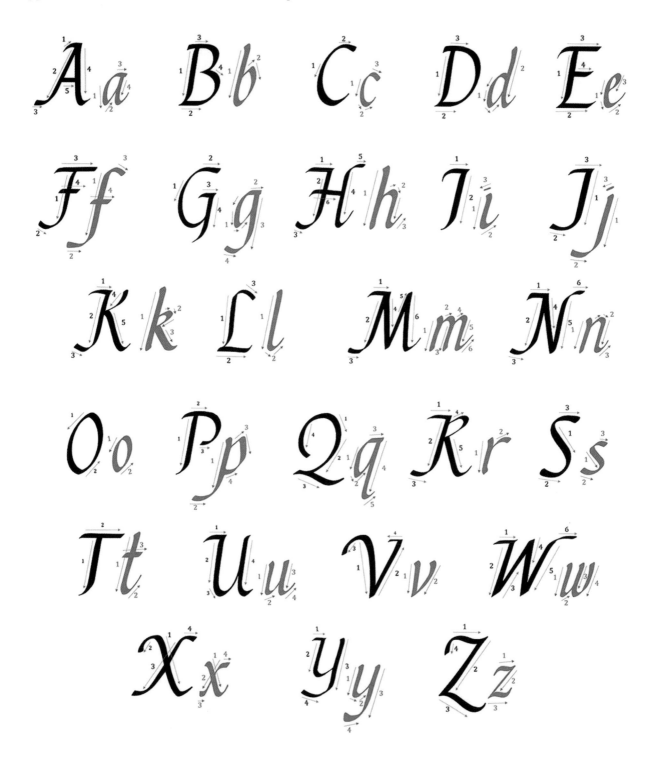

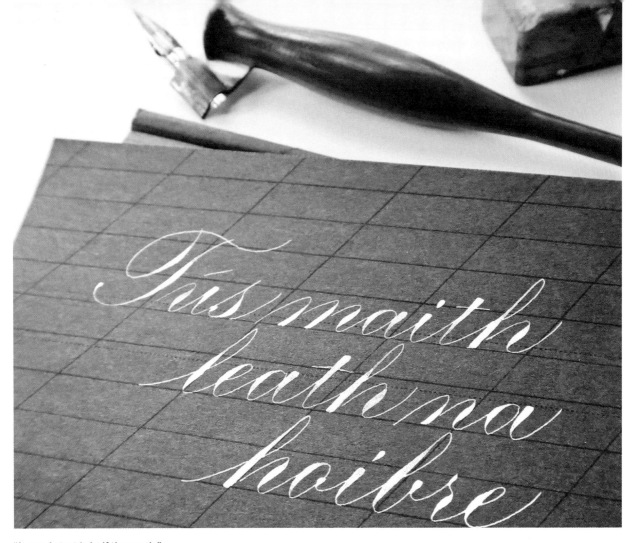

"A good start is half the work."

Copperplate

When England started to establish itself as an economic power in the mid-seventeenth century, the growing business class increased the demand for education in writing and bookkeeping. The printing methods of the time also helped shift styles from the italic hands of the fifteenth and sixteenth centuries. The pointed burin used for engraving the printing plates made the letters more rounded and slanted, and the contrast between thick and thin lines more prominent. The plates were made out of copper, hence the birth of the term copperplate. Following the changes in the letters by the plate engravers, scribes then carved and sharpened their pens to match the new hand. This style is also called engraver's script.

Copperplate was preferred for its practicality (speed and legibility) and its beauty. During almost four centuries of use, there have been a few changes in its execution, but the basic aesthetic is largely the same.

Perhaps the most notable collection of examples from the mid-eighteenth century is George Bickham's *The Universal Penman*. The book has over 200 samples of written work from the finest calligraphers in England, all engraved by Bickham to be published for scholars and subscribers. This book, now published by Dover Publications, is a true inspiration to anyone studying this script.

In the United States, Charles P. Zaner, founder of the Zanerian College of Penmanship in Ohio, published numerous books and instruction manuals in the late nineteenth century. These include *Lessons in Engrosser's Script* by Zaner himself, and *The Zanerian Manual*. These books inspired most of the instruction in this section.

The basic strokes here comprise the small letters or miniscules. In copperplate script, each pen movement is controlled and precise. Do not depend on the fingers all the time, because they will cramp easily. Use your forearm and keep your wrist flexible in order to push and pull your entire hand over the page. Observe the slanting of the letters and work to keep them consistent. The copperplate slant is 55 degrees.

The Universal Penman, Engraved by George Bickham, London, 1743. Dover Publications, Inc., New York, 1954.

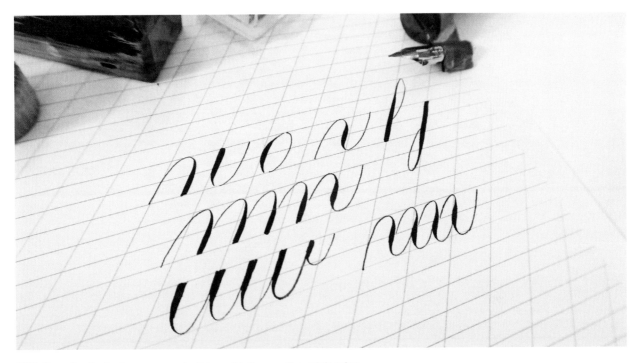

With these basic strokes, you can build small letters or the miniscules.

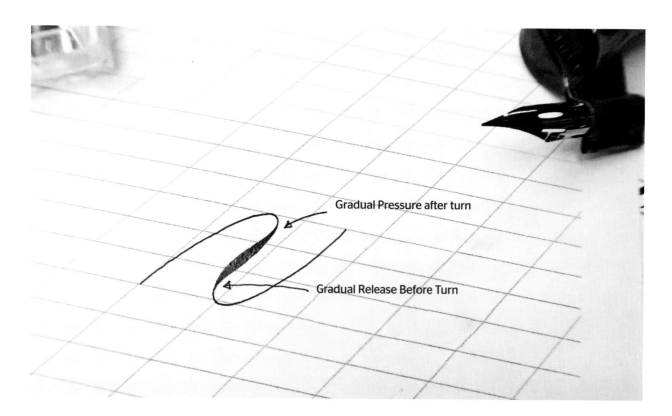

Gradual Pressure after turn

Gradual Release Before Turn

Use your fingers to make the turns and the tight loops. Start to taper your heavy shade even before you reach the baseline or make a turn. The gradual release of pressure helps you avoid catching paper fibers or ink blobs when you snap the nib back at the last minute.

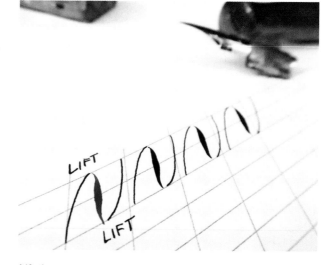

Lift the pen to help learn to control transitions.

Likewise, be careful in applying pressure when switching from a light stroke to a heavy one. Make it gradual so the ink doesn't gush out of the nib.

If you are having a hard time with the transitions, lift the pen between the strokes. In fact, the strictest form of copperplate involved lifting every time at the baseline or between strokes. Do not rush, take your time.

The exit strokes are just as important as the letter itself. If you learn control in these strokes, you can connect letters in words more cleanly. If done half-heartedly or in a rush (like the end of a check mark), it's not going to look very balanced.

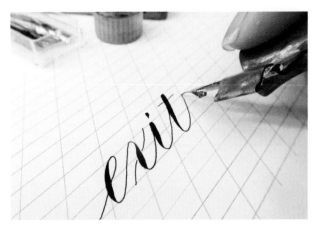

Exit strokes should be completed with as much care as the initial strokes.

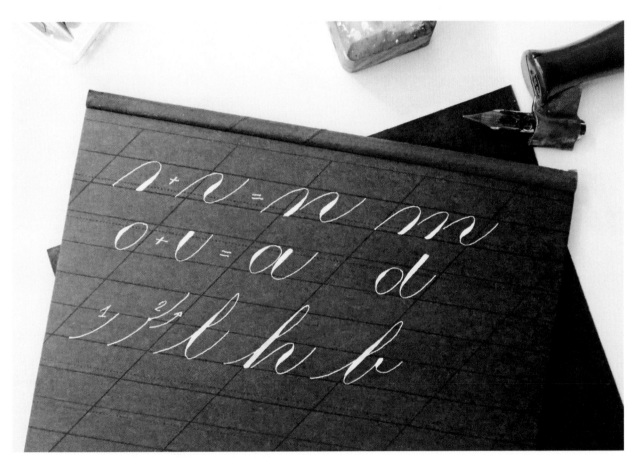

The miniscules are combinations of the basic strokes.

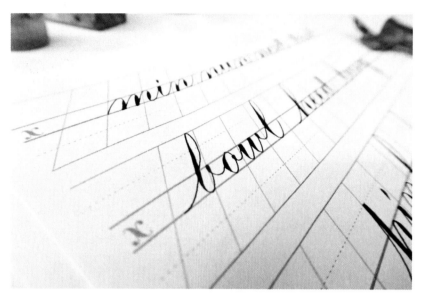

Make sure your forms hit the lines—baseline, midline, and topline—when it applies.

Putting together the fundamental strokes discussed previously will have you writing the small letters. Practice with small words first, before attempting longer ones. Pay attention to the consistency between strokes and letters. A steady rhythm contributes a great deal to the beauty of the script.

The writing of the capital letters, or majuscules, depends highly on the execution of the capital stem, which is also called a compound curve. Visually, it may look like an S, but it actually is a straight line with swells tapering at the top and bottom.

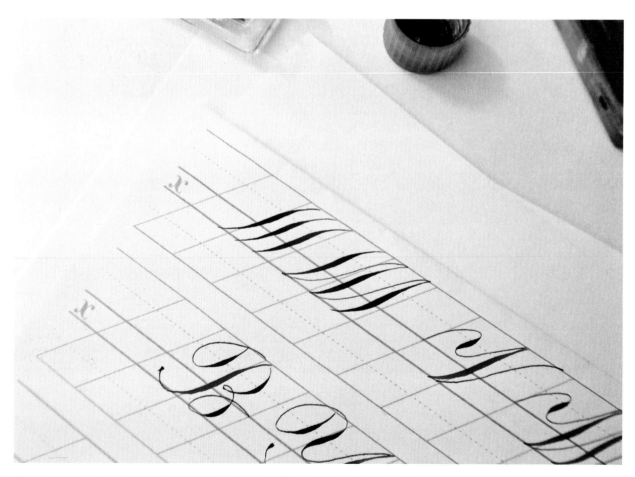

The capital stem is essentially a straight line down with the swell tapering the ends.

In order to create a capital stem, start with a light point, then carefully add pressure as you go down toward the midline. Then decrease pressure so it diminishes to a hairline when you reach the baseline.

The following photo shows how the stem appears in almost all the capital letters. The more you practice the stem, the better you will get. However, don't be ashamed of your mistakes! Making and correcting mistakes are the only ways you will learn.

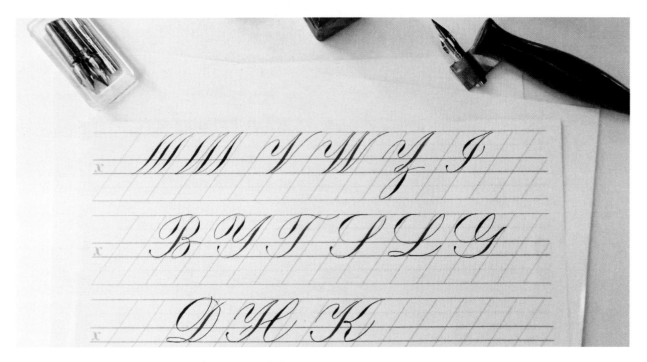

Note how the stem appears in most of the majuscule letters.

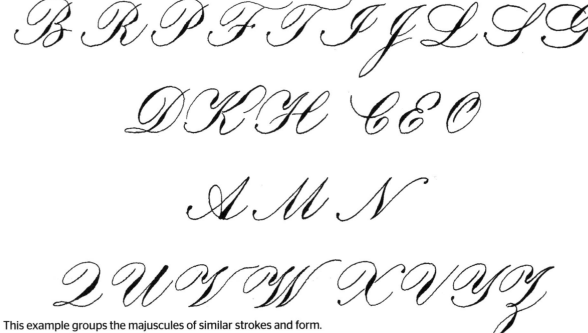

This example groups the majuscules of similar strokes and form.

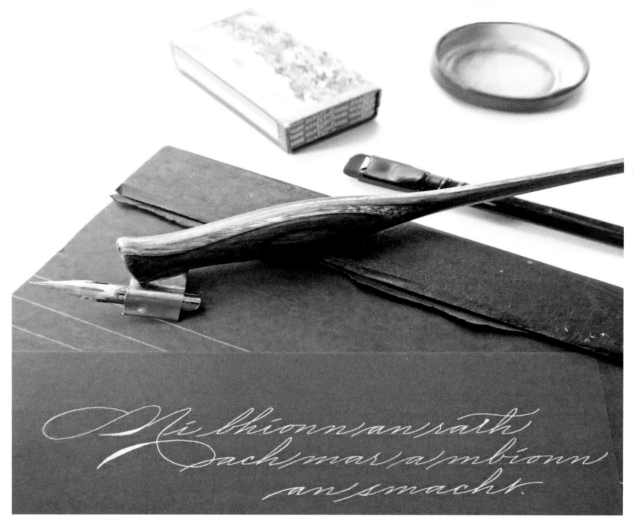

There's no success except where there's discipline.

Spencerian Calligraphy

Platt Rogers Spencer (1800–1864) developed this beautiful, flowing style of writing that bears his name. In the early-nineteenth-century United States, trade and industry was booming. Copperplate was still widely used, especially for bill heads, advertising, matters of state, resolutions, and policies. But the shaded script required dexterity. Spencer's writing system encouraged freedom of movement. When it was established, it became a force in education and promotion of literacy as well as in business. The acceptance and growth of this new system also marked the start of America's golden age of handwriting (1850–1925).

What makes Spencerian different from copperplate? The script is generally without shading, with swells prominent only in the capital letters. How one shades, and by how much, is left to the individual arist, which makes it easy to personalize.

This is a system that encourages gentle and free-flowing lines with wide spacing. Spencer was largely inspired by curves found in nature and we can see this in the open, elliptical shapes of his letterforms. The omission of heavy shading on every stroke gives the script its delicate and graceful appearance.

The wider spaces between strokes are for the speed of writing and legibility. Learning how to make the letters flow can be practiced through cross drills. The exercise helps your hand acquire a smooth and light rhythm. First, write the letters or word on the lines, then turn the paper to write them across the perpendicular. Start with small groups, with five lines of four letters crossed with another four letters (5 to 7 times across). Short words may also be used.

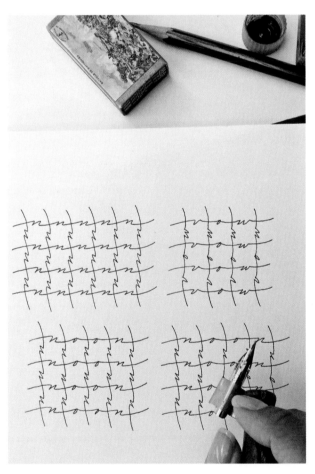

Cross drill exercises train your muscles to move with ease. Short words are also great exercises for practice.

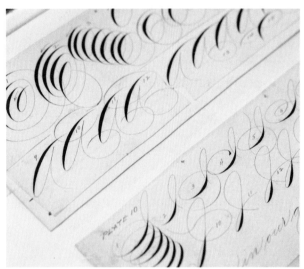

Exercises penned by C. P. Zaner from the collection of Michael R. Sull.

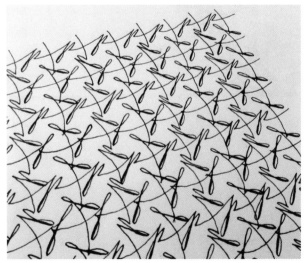

You can do cross drills with two similar letters, like *p* and *f*.

Use your forearm muscles to glide the hand across the page, with the fingers assisting in curves or loops. If your wrist isn't flexible of if you grip the pen too tightly, you will not be able to link forms freely. Remember that these are movement exercises, so form takes a back seat. Don't worry if your form isn't perfect, it'll get better in time.

The wonderful thing about Spencerian hand is that whatever writing instrument you use, the forms will remain the same. Because it doesn't have shades you can practice with colored pencils or a regular ballpoint. You can use colors for interest while cross-drilling, too!

Another way to study spacing and the sliding motion is to use your regular lined paper crosswise. At right and below are a bit of drills done from the book *Modern Business Penmanship* by Edward C. Mills (published in 1903).

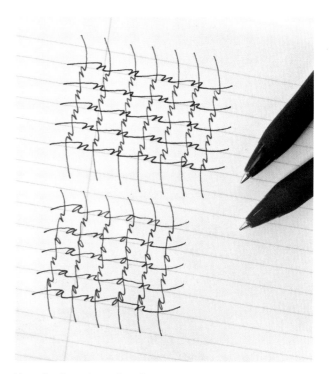

Have fun by using colored pens or pencils!

You can practice with your pad crosswise to study spacing and movement.

What makes Spencerian script different from the roundness of copperplate is the joints that hinge the letters together, which are called soft turns. Examine your writing to see if your turns look too sharp. They should curve slightly, like a bent elbow.

Make the minuscules flow by keeping your hand and grip light. Bear down only when there are shades, like in the d and the t, and some descenders like y, g, f, and p. You don't need to practice shading if you're new to this, nor do you need to write with speed at the onset. Focus on forms and getting a comfortable pace. Speed will come later, when your muscles are more familiar with the movement.

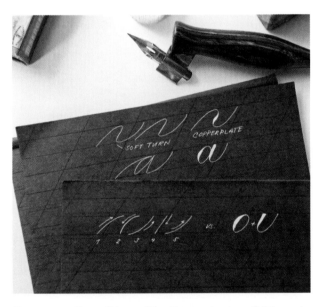

Can you see the soft turn of the Spencerian hand? It is made up of a smooth succession of lines, rather than copperplate's combination of drawn shapes.

Mark the exercises you think are good and those that need improvement, so you can fix them next time.

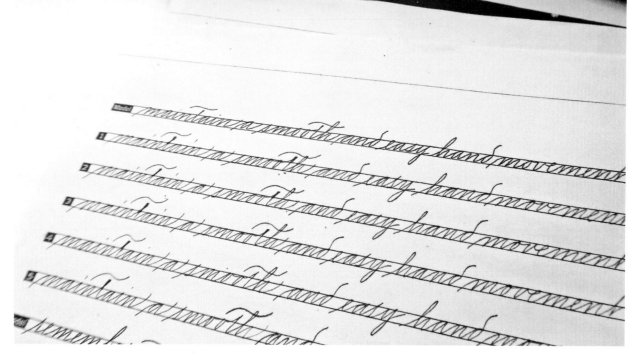

In penmanship schools, copybooks were popular. The teacher wrote the model on top and the student filled the lines below for practice. Here is a filled-out practice sheet from the *Spencerian Practice Set* by Michael R. Sull.

The capitals are simple, yet elegant. The secret to getting the script just right is to practice the oval or the capital O. The rotating movement, both clockwise and counterclockwise, is present in almost all the Spencerian capitals. The example of the majuscules here also includes the basic stems you can practice.

Because Spencerian script was intended for business and education, flourishes and such elaborate strokes are kept to a minimum. A dramatic variant of Spencerian called ornamental penmanship, however, can be a showcase of proficiency and skill.

The style is extremely elaborate, yet seamless. How artists wrote their signatures was considered the height of ornamental penmanship. But do note that under all the flourishes and decorations are the correct forms of Spencerian letters.

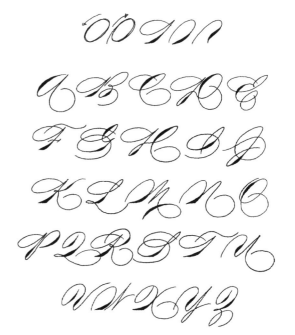

This example includes exercises and the basic capital stems for the Spencerian majuscules.

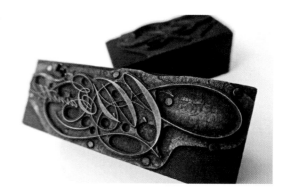

Print blocks of calligrapher's signatures from the Zanerian College.

There are two main rules for executing these flourishes or what are called superscriptions. 1) They are based on ovals and curves, and 2) heavy strokes or swells never intersect. Great inspiration for this dramatic script are the works of Louis Madarasz, C. C. Canan, and of course C. P. Zaner and P. Z. Bloser (see Resources, page 182).

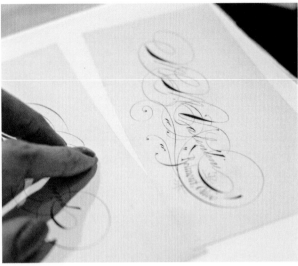

Writing of M. M. Valentine, from the collection of Michael R. Sull.

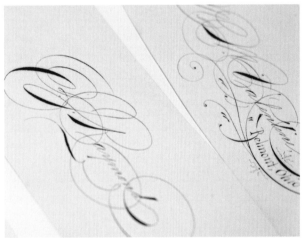

Writing of Valentine and Raymond, from the collection of Michael R. Sull.

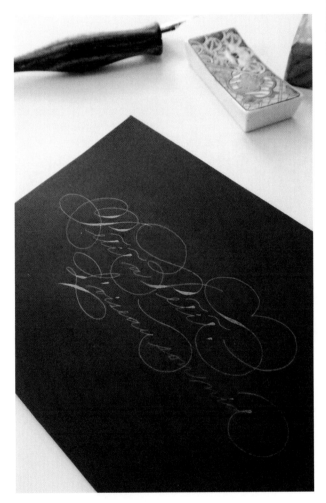

Artistic writing inspired by the style of C. C. Canan.

Blackletter Calligraphy

by AJ Tabino

Blackletter, which is also called Gothic or Old English, involves a variety of calligraphic styles. Some calligraphers favor this style because of its feeling of drama with its dark letterforms full of impact and contrast. Blackletter is characterized by uniform, upright, or vertical strokes, and various built-up serifs. Though one of the most popular hands in calligraphy, blackletter is best for short texts, as it can be tough to read in large portions.

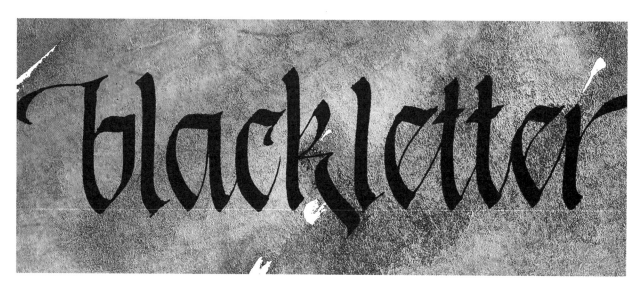

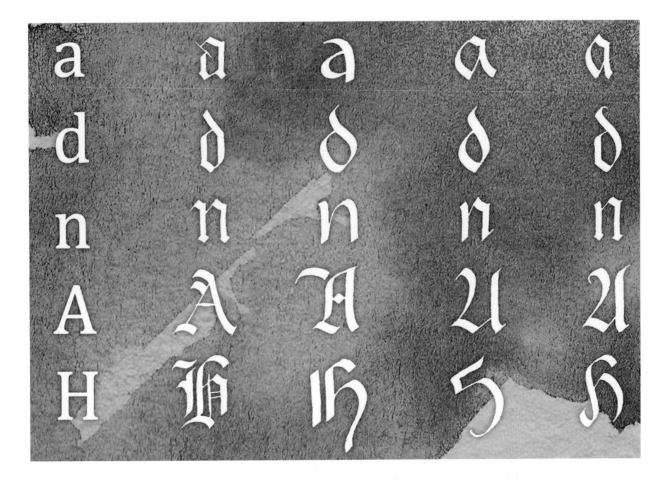

Used throughout Europe from around the eleventh century, most of the black letter letterforms were based on a style called Carolingian minuscule. This was developed to provide consistently legible books and publications. However, as printed literature became more widespread, Carolingian miniscule could not keep up. It took too much time and labor to make. It was replaced by black letter, which was the standard hand used to print books. From there, four major classic styles of blackletter emerged: textura, rotunda, schwabacher, and fraktur.

To this day, varieties of blackletter are still evolving. Its development is driven by each practitioner who adds their own character to the hand.

Getting Started

Starting out with black letter can be confusing, at times, considering the various styles available. But you will soon see that those styles have more similarities than differences. In this demonstration, we will use textura hand using a 3.8-mm size parallel pen.

Guide Preparation

Guides can be daunting, but they are a great reinforcement as you understand how letters are formed.

A common nib-width ratio for a blackletter guide is 2:4:2. But for this demo, we will be using the 3:5:3 ratio. This means three nib widths for both the ascender and descender, and five nib widths for the x-height. This ratio is most compatible with the pen and hand that we will be using.

You can create your own guide, and experiment with different guide variations. Guide sheets are available on page 162–163. The purpose for a guide is to help you develop proper execution of the letters.

Pen Angle

Among other things that you need to think about when starting out is the pen angle. A good angle for writing in blackletter is 45 degrees. Once you have a flat-tip pen, however, try different angles to see how a slight change in position affects letter structure. Although calligraphy enthusiasts prefer different angles (which is fine), you must be consistent once you've chosen your pen angle. A consistent pen angle will allow you to achieve the letterforms that you want.

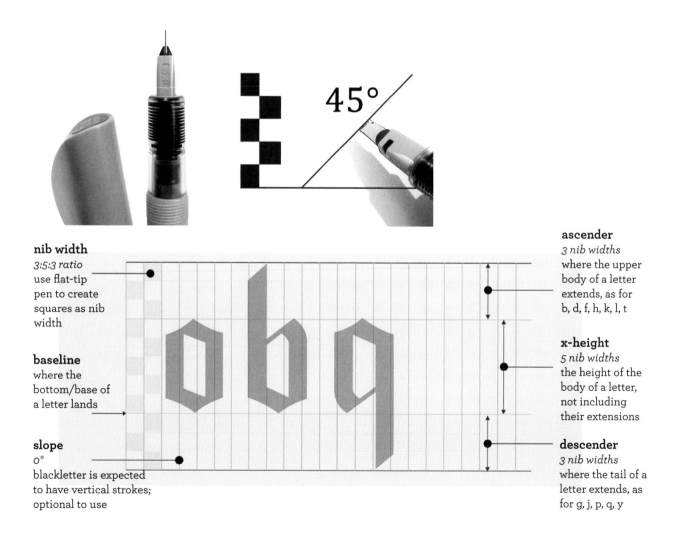

45°

nib width
3:5:3 ratio
use flat-tip pen to create squares as nib width

baseline
where the bottom/base of a letter lands

slope
0°
blackletter is expected to have vertical strokes; optional to use

ascender
3 nib widths
where the upper body of a letter extends, as for b, d, f, h, k, l, t

x-height
5 nib widths
the height of the body of a letter, not including their extensions

descender
3 nib widths
where the tail of a letter extends, as for g, j, p, q, y

Basic Strokes and Concepts

Black letter alphabets are made up of stroke combinations. Once you learn the individual strokes and get used to the feel of the pen in your hand and on the paper, you will be well on your way. Check the following basic strokes.

When creating these basic strokes, make sure you hold the pen firmly, but not so tight as to cause strain. Make sure your angles are still on point, even when shifting to another stroke. Press, relax, and pull.

Thin Upstroke
Position your pen in an upright manner, then drag it going up

Thin Downstroke
Position your pen in an upright manner, then drag going down

Diamond
Angle your pen at 45° then slowly drag/slide to the left

Thick Downstroke
Maintaining now at 45° pen angle, drag the pen down

Side/Dash Stroke
Drag the pen across the paper to the right

Flag Stroke
Thin upstroke first, then without lifting the pen off the paper, slightly slide going down to the right

Wave Stroke
Start with an upstroke, let the pen dance by continuing a downstroke, then going up again

Overturn
Start with a thin upstroke, then an abrupt turn for a downstroke (no lifting from the paper)

Underturn
Still angled at 45°, slightly drag going down, then make a turn going up (no lifting from the paper)

Letter Structure

If you are having a hard time with this hand at any stage, you can always go back to doing basic strokes.

Starting out with rigid forms can be an adjustment for people who are used to only regular writing. The flag stroke is a good place for beginners to start because it is a launching point for all other strokes, much like the entrance stroke for doing copperplate. This rigid form will help you learn how to adjust from regular writing to stricter hands.

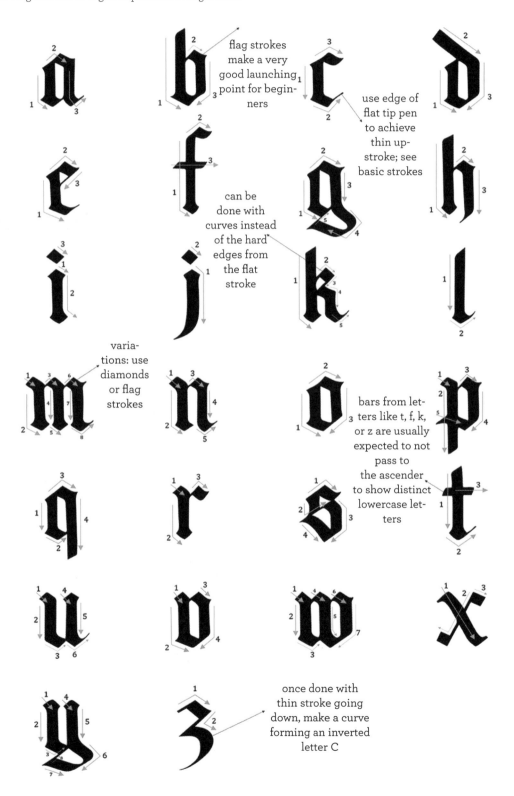

flag strokes make a very good launching point for beginners

use edge of flat tip pen to achieve thin up-stroke; see basic strokes

can be done with curves instead of the hard edges from the flat stroke

variations: use diamonds or flag strokes

bars from letters like t, f, k, or z are usually expected to not pass to the ascender to show distinct lowercase letters

once done with thin stroke going down, make a curve forming an inverted letter C

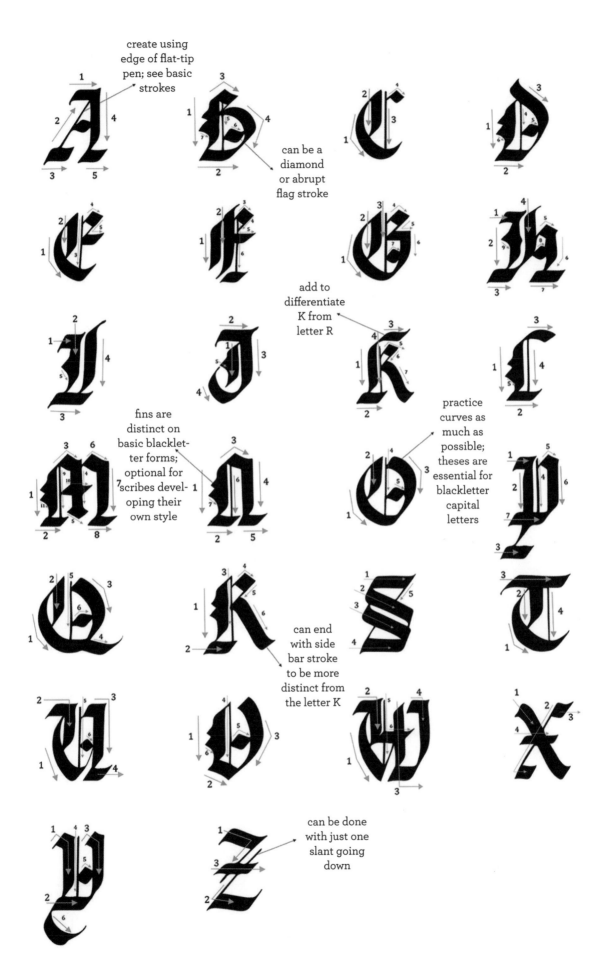

create using edge of flat-tip pen; see basic strokes

can be a diamond or abrupt flag stroke

add to differentiate K from letter R

fins are distinct on basic blackletter forms; optional for scribes developing their own style

practice curves as much as possible; theses are essential for blackletter capital letters

can end with side bar stroke to be more distinct from the letter K

can be done with just one slant going down

Roman Calligraphy

by Jelvin Base

Modern roman capitals are derived from letters that are seen inscribed on monuments in ancient Rome. Compared to its traditional counterpart, modern roman capitals are modified for writing with pens rather than brushes.

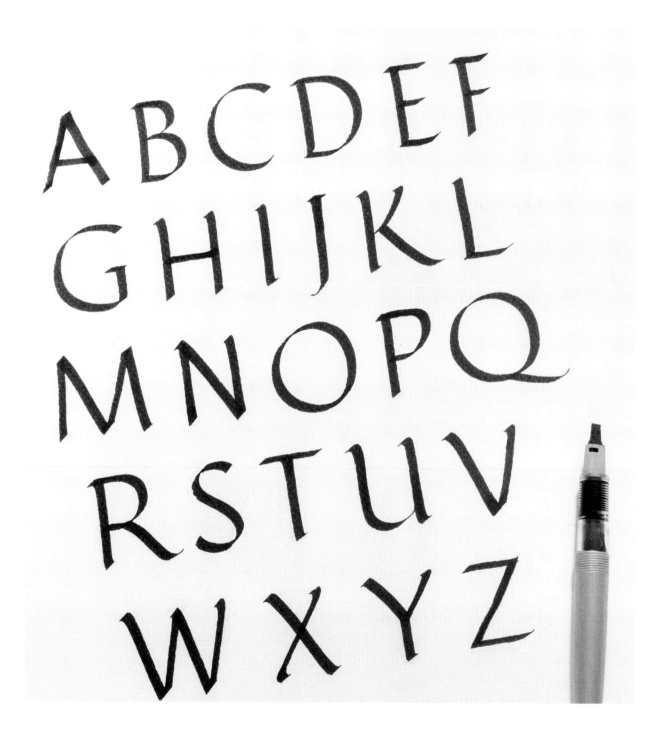

The letter E on the left is an example derived from the alphabet of ancient Rome, and the letter E on the right is an example of a letter from the modern roman alphabet. Do you see any differences between the two forms? In order to adapt the modern roman alphabet to use with pens, the letters are written with strokes moving vertically, horizontally, diagonally, as well as in ovals and curves.

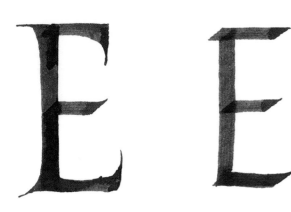

Tools

The main tool that is needed to write modern roman capitals is a chisel/flat/broad-edged pen. Most of the time, you can find broad-edged nibs, flat brushes, and calligraphy pens in your local craft or art store, but if you can't find any of them, you can try sticking two pencils together with a rubber band or a couple strips of tape.

The most important thing here is to be resourceful with the things that you have to kickstart writing the scripts that you want. Grab anything that's available at your disposal and budget.

In the photo, you can see different types of tools that you can use to achieve creating modern roman capitals:

- Double pencil
- Homemade calligraphy pen using aluminum soda cans
- Felt-tip calligraphy pen
- Broad-edged nib with a holder
- Steel-tip calligraphy pen
- Flat sable brush

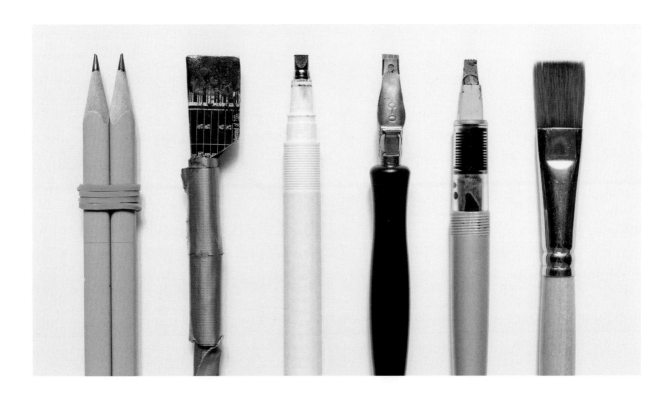

How to Write with a Broad-Edged Pen

A chisel/flat/broad-edged pen is not used the same way ordinary pens are. The trick is to practice writing with the tip flat on the paper. Do your best to write slowly, making sure the whole tip is flat on the paper to maximize the width that the pen can achieve. It might feel uncomfortable, at first, but once you get the hang of it, you'll be writing strokes like the ones in the photo to the right.

Some beginners tend to push and press the pen onto the paper with too much force. Don't worry if can't get it on your first try; try to get a feeling for the tool that you're using, and the rest will follow.

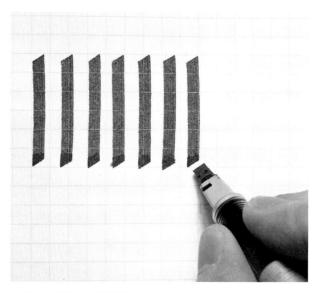

Pen Angles

When writing in modern roman capitals, keep your pen at the same angle throughout your stroke. This is true for black letter and italics, as well. The pen angle affects the overall form of the letter when you're writing, and for modern roman capitals, the angle of the pen should be between 30 and 40 degrees. No need to break out the protractor—you can eyeball it.

In the example below to the right, the first letter is written in a pen angle of around 30 degrees, the second letter is around 70 degrees, and the last letter is around 15 degrees. There's a significant difference in appearance caused by simply changing the pen angle.

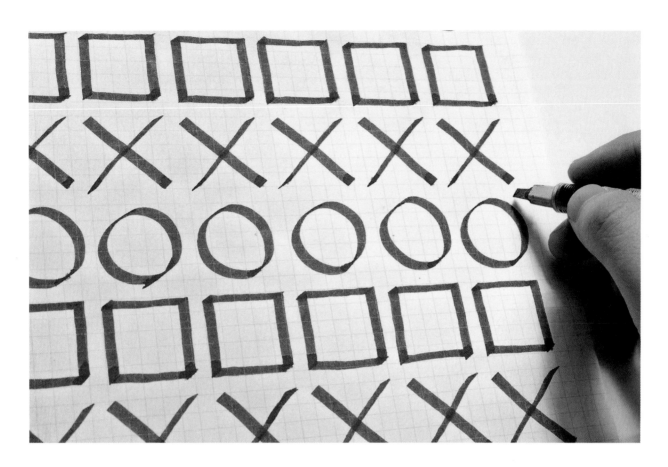

Warm-ups

I know you're itching to write some letters, but let's get our hands familiar with some strokes first.

The main strokes used in modern roman capitals are vertical strokes, horizontal strokes, diagonal strokes, and circular/oval strokes. The examples above consists of the majority of strokes that we'll be using when we're writing the letters.

These warm-ups kill two birds with one stone. Not only are we preparing our hands for further writing, we're also getting to know the strokes that comprise the letters in the alphabet.

Try doing the drills pictured in the photo. The practice strokes are straightforward: do your best to draw a square, a cross, and an oval. Also, keep in mind your pen should be at an approximately 30-degree angle. Warm-ups can be repetitive and boring, but if you put in enough time, your writing will improve greatly.

Letter Proportion

There are three calligraphic and typographic terms that we need to learn so that we'll have an idea on how to write letters proportionally:

- Baseline
- Cap height
- Number of nib widths

The baseline is where the letters sit when we write. The cap height is the line that shows the height of the letters. We now know what the cap height is, but how do we determine how tall the letters should be? We refer to the number of nib widths.

The number of nib widths determines the proportion of the letters given the size of the nib, which are the squares that you see to the left of the word in the image below. For modern roman capitals, the number of nib widths that we need to prepare is eight. Just stack the squares into a staircase structure if you have a hard time doing the alternate ones.

Plotting the number of nib widths from the baseline determines the cap height so we can write letters proportionally. In the photo, you can see the difference between a well-proportioned letter and letters that aren't given enough clearance. It's difficult to write modern roman capitals if the cap height is less than eight nib widths.

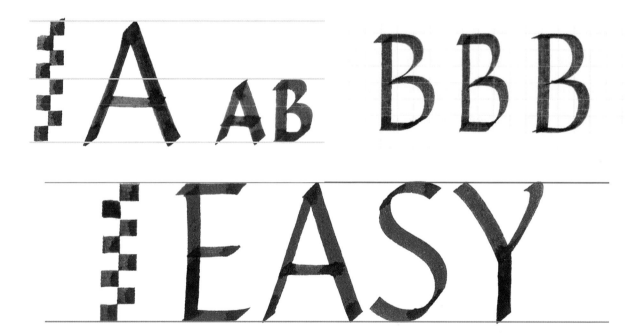

Alphabets and Genealogy

Now it's time to write some letters!

You might wonder why I arranged the letters in this way and not in alphabetical order. These letters are sorted by their letter groups or genealogy so it is easy to determine the shapes that go with every letter. Can you spot the strokes within the letters? Do you notice how the letters are similar to the warm-up strokes?

The letter groups are arranged by the complexity in the combination of strokes; e.g., letter I is the easiest because you only need one stroke to write the letter. Following the order of strokes that we tackled in the previous section, we'll do the letters with horizontal and vertical strokes first, then move on to ones with diagonals and ovals. You'll notice that the warm-up strokes that we did earlier form the letters that we're going to write.

- I J L T H F E
- V A W X M N Z K Y
- P R B
- D C G O Q
- S U

Do your best to follow the stroke orders and go through the alphabet from the simplest letter to the most complex. Don't forget to do things slowly until you can get the strokes that form each letter

I J L T H F E
V A W X M
N Z K Y
P R B
D C G O Q
S U

A B C D E F
G H I J K L
M N O P Q
R S T U V
W X Y Z

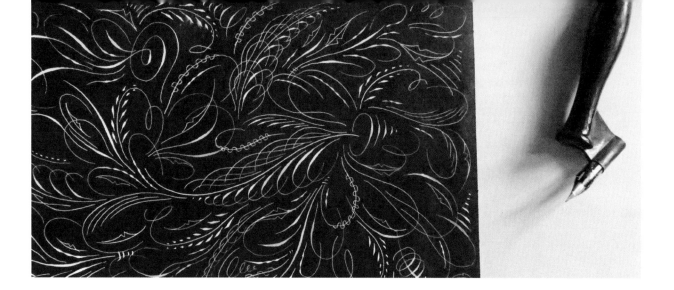

Offhand Flourishing

Offhand flourishing is a component of ornamental penmanship, and shows the artist's skill and creativity. With the rise of the elaborate scripts, calligraphers began using flourishes to create works of art beyond just letters.

The primary designs were of birds, plumes, cartouches, scrolls, and various foliage. These were used to decorate things like diplomas, advertisements, greeting cards, and were published in various magazines devoted to the craft of penmanship. The birds and small accents can also be used to decorate titles and headings. They are seen here as ornamentations to student name tags.

You can use either a straight holder or an oblique. Traditionally, a straight pen is held so that strokes are made moving away from the body. Heavy shades are made exclusively outward. If you are more comfortable with an oblique holder, feel free to use it. You can also make swells toward your body if this is easier. Don't forget that you can turn the paper, too!

Nametags penned by Master Penman Michael R. Sull.

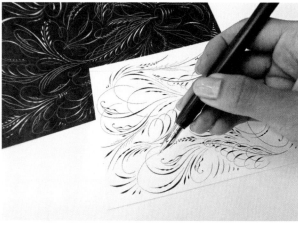

An example of how to hold a straight holder.

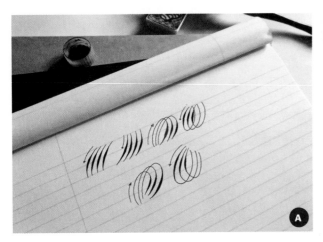

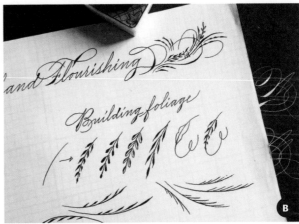

Attempting to flourish may look very scary. But the key is to focus only on the stroke that comes before and not worry too much about anything else first. Practice strokes in groups of three (A). Try to keep the swells parallel, using the stroke before as a reference.

If you examine flourishes, you'll notice that they are merely a bouquet of repeating lines in different sizes. And a simple curved line can be turned into foliage (B).

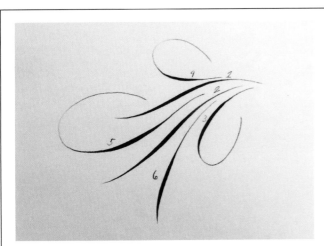

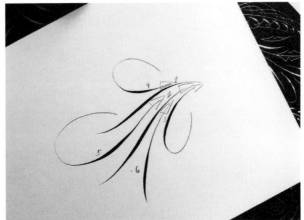

The Cartouche—Take this simple cartouche, above, for example. A cartouche is a collection of at least three curves that make a unified design. There are six strokes in the sample, made in the numbered sequence. We start with a compound curve, just like a copperplate capital stem. The following strokes all bisect a V space. Can you see them?

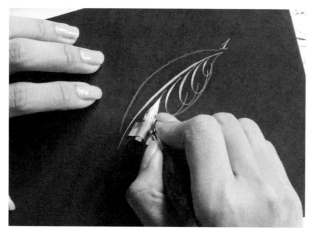

You'd also see a lot of quill designs, because it was the symbol and main tool for calligraphy. For beginner's practice, let us assemble something similar: a leaf. The first stroke is a curve and you could put in a swell or just make a monoline. Working on the right side first, turn the paper so the swells come toward your body (or away, if this is your preference). Now the fun part! These half-ovals don't need to touch the main stroke. Do start with a hairline first, then swell, then taper when you curve. The gradation of the sizes can follow a pencil guide of the shape. Note that no shades intersect.

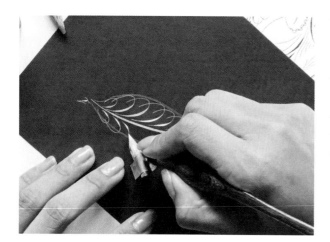

When you're done with the right side, turn the paper so it's easier to do the strokes for the left side. Go through the same exercise of filling up the space. Make it as sparse or dense as you want. Feel free to study old flourishing examples to see the many ways you can fill in a quill space! Notable works include that of F. B. Courtney, W. E. Dennis, C. P. Zaner, and Michael R. Sull.

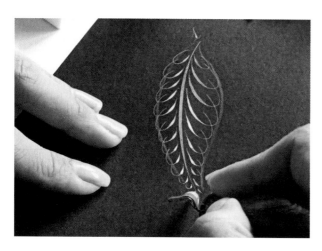

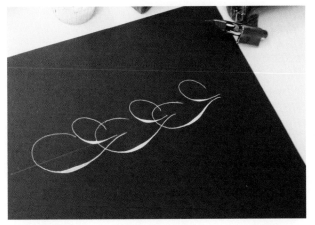

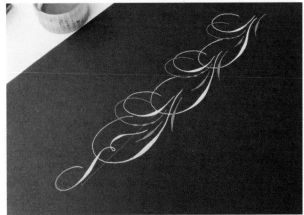

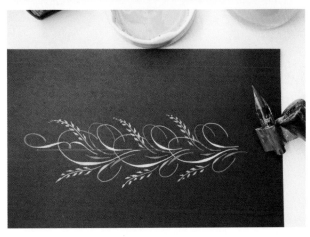

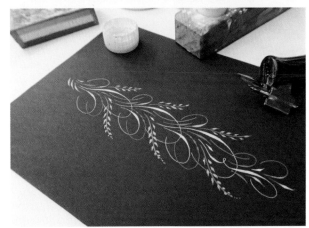

Flourishes are often used in border work and headings. Expanding a pattern lengthwise involves the repetition of strokes in a line. The steps in the photos above were done in different colors to show the progression.

The practice of offhand flourishing is a freeing one. You don't need to worry about slants or letterforms. Be inspired and have fun with it. Experiment with color combinations and shapes. As with anything, skill comes with practice. So, enjoy and flourish freely!

Project

by Geli Balcruz

···· TIP ····

Avoid overmixing the watercolor as this may ruin your paper.

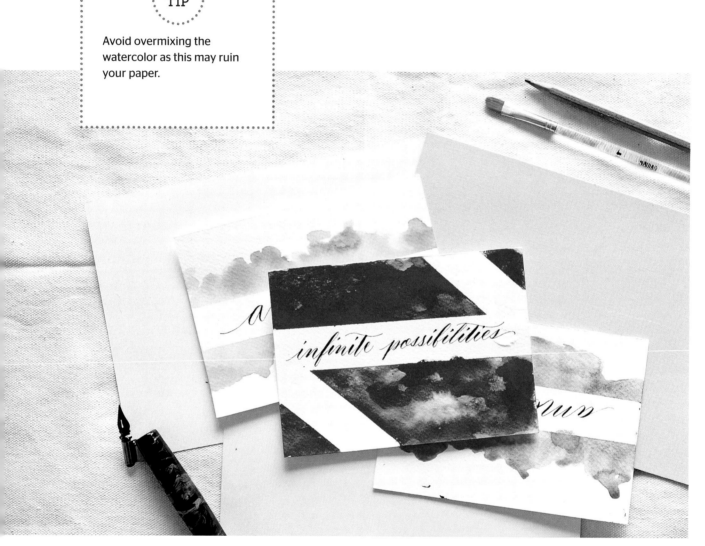

NAME CARD

Add an artistic touch to your name cards with a fun watercolor wash.

MATERIALS

- watercolor paper
- watercolors
- brush
- nib
- nib holder
- ink
- pencil
- washi or masking tape

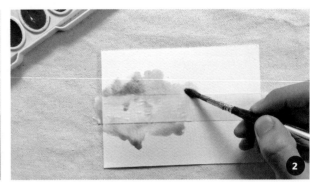

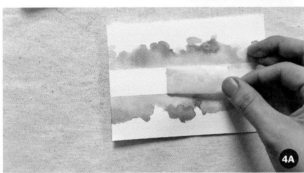

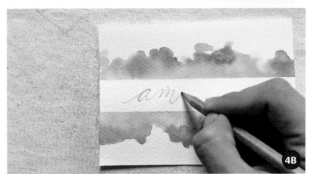

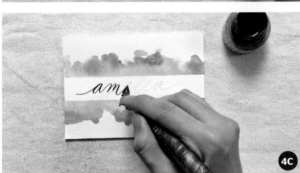

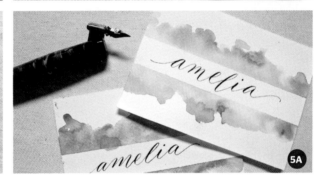

1 Place a strip of washi tape across the middle of your watercolor paper.

2 Decide on the colors you'll use for your watercolor wash. You can use a single color or two or three mixed colors. Applying the wet-on-wet technique*, start creating your watercolor wash around the washi tape.

3 While waiting for your watercolor wash to dry, decide on what calligraphic style you'll use on the middle part. It can be a fun freehand or a strict italic—whatever you prefer!

4 Once the watercolor paint is dry, gently remove the washi tape to prep it for writing. On the clear part of the paper, you can use your pencil to draft your name or you can immediately write on the notecard using your dip pen.

5 Allow a few minutes for the ink to dry.

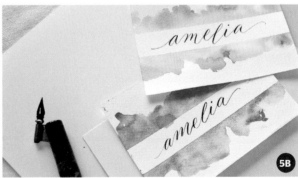

* A method in which fresh (wet) paint is added to an already wet surface, resulting in colors with soft, fuzzy edges. Make sure your paper is thick enough to absorb water so it doesn't buckle and use a clean sponge to dampen the area before adding your color(s).

Modern Hand Lettering

The art of using a brush for lettering has been around since the early 1800s, when sign painting became widespread. This style was used mostly for announcements and ads, and is now a staple in custom lettering styles.

In recent years, there has been a resurgence of all things hand drawn, which allows artists and designers to incorporate these elements into their creative process. Moreover, modern tools have made it easier to practice modern hand lettering, giving us the capability to more easily produce letterforms that resemble older styles. What's interesting about modern hand lettering is that every letterform looks unique, as we each have our own respective handwriting that is reflected in the strokes we create.

In this chapter, we will tackle the essence of modern hand lettering, using both traditional and modern tools to come up with various styles; mastering basic script; adding "bounce" to your letters and layouts; using flourishes, flowers, and leaves to enhance your work; and incorporating your hand lettering into fun projects.

Start by using a pencil or fineliner pen to work on scripts, unless you are intent on using a brush-tip pen for thick and thin stroke variety. For paper, use anywhere from 60 to 80 gsm for ink and 200 to 300 gsm for watercolors. Depending on your paper choice—for beginners especially—the weight measurements will limit the strokes you can produce.

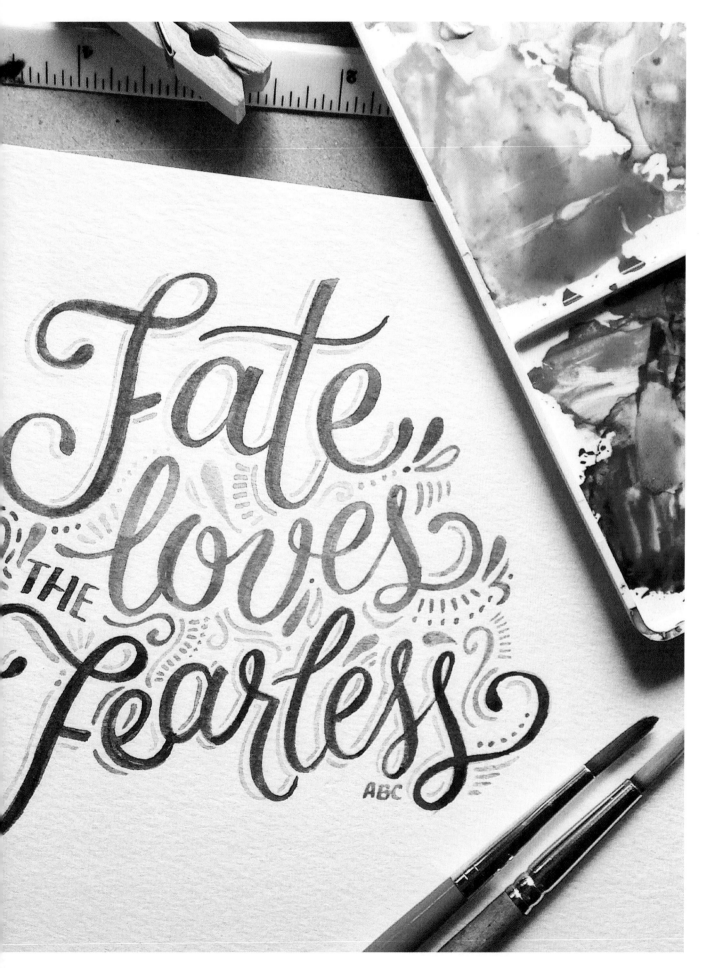

Fate loves the fearless

ABC

Using Traditional Tools

Before commercial printers, signs were lettered with brushes. Paintbrushes originated in China around 300 BCE, with the advent of calligraphy, and eventually spread across the other continents. Paintbrushes were common in lettering—especially for writing script fonts.

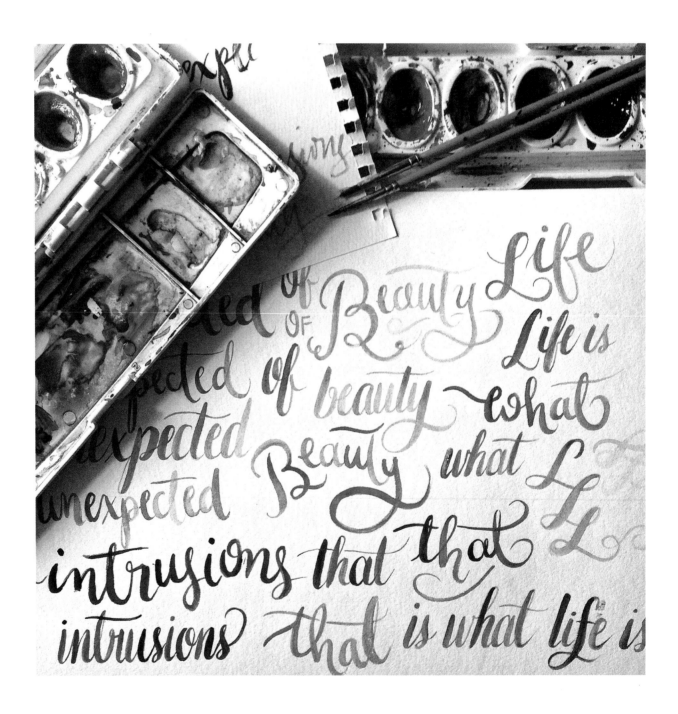

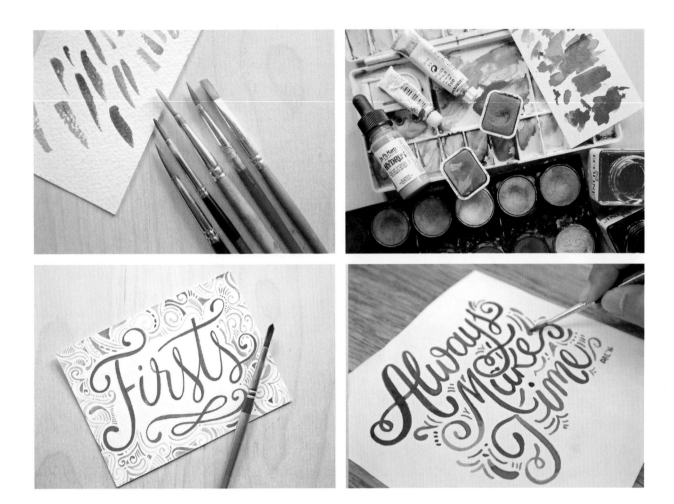

Round brushes are commonly used because their shape allows for both thick and thin strokes. Liner brushes are used for detailing and drawing thin script fonts. Flat brushes are most useful for bold strokes that required a squarish tip.

Using Modern Tools

With the popularity of analog writing in the digital age, there has been a sudden influx of modern tools to the market. Updated classics and completely new tools enable artists to experiment with more styles and techniques, adding to their modern hand-lettering skill set.

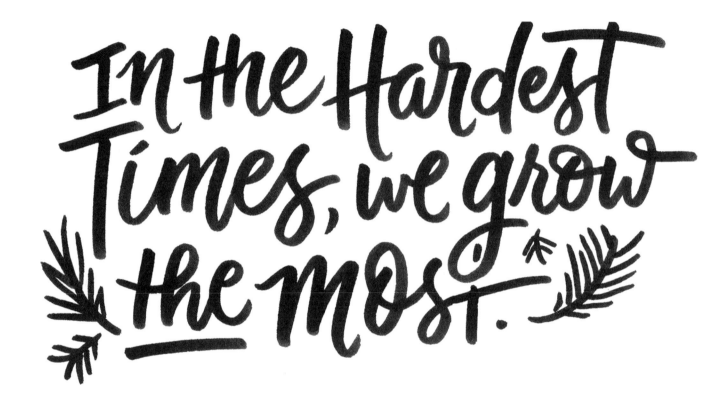

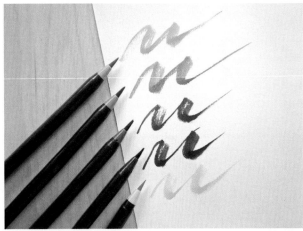

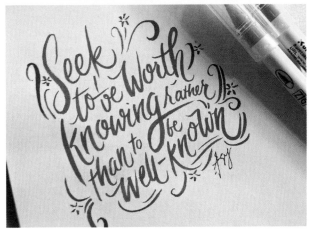
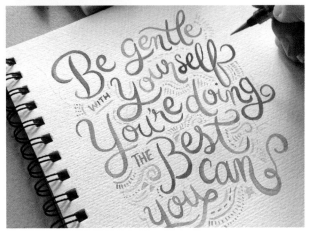

Nowadays, paintbrushes are most often made from synthetic (nylon or polyester) hair, and are low maintenance and beginner friendly. Paint options have expanded exponentially as well, with the rise of watercolors available in pans, tubes, and in concentrated forms.

New brands of brush pens and markers have helped artists transition from traditional round-tip brushes. This, in turn, gives artists the opportunity to develop looser and more freeform lettering styles in their work.

A notable characteristic of modern brush lettering is its variety in terms of style. Modern brush lettering takes its inspiration from traditional calligraphy and adds a creative do-it-yourself aesthetic to lettering. This chapter will show you how to create lettering for the page, the plate, and even the back of your smartphone!

Basic Script

Basic script comes from the fluid strokes created by our own cursive handwriting. Its main characteristic is the connection of each letterform derived from the classic, flowing scripts of calligraphy—although some script fonts tend to have separated letterforms. Mostly used for display rather than body text, script fonts come in both formal and casual styles.

Formal

Congratulations

YOU'RE Invited

A vaillant coeur rien d'impossible

For a valiant heart, nothing is impossible.—Jacques Cover

Formal Script

Formal script originated from calligraphy in the seventeenth and eighteenth centuries. The strokes are usually angled to the right, and all letterforms are connected in each word. The letters in this form were originally written with a quill or metal nib, which can create both thin and thick strokes. Nowadays, this script is used for special occasions, including lettering on diplomas and fancy invitations.

Casual

we're
Open

Il vaut
mieux faire
que Dire

GREAT!

Doing is better than saying.

Casual Script

Casual scripts emerged in the twentieth century, and have been used for advertising and sign making. Each decade has its own style of scripts and many styles reappear in a retro fashion, becoming new again. The letters in this form are mostly written with a wet brush, making it looser than formal scripts. With its informal style and modern approach, this font style can have varied width strokes, as well as nonconnecting letterforms in each word.

Warming Up

Practice with your strokes and lines, and keep them loose. It's important to have a good grip on your pencil or pen, similar to how you hold it when writing. Start by writing A to Z in both uppercase and lowercase styles. Note that some letters can change, depending on how you learned to form them. Don't worry about any variations you see between your own letters and the guidesheets. Make your style your own!

Below is an example of a basic script alphabet.

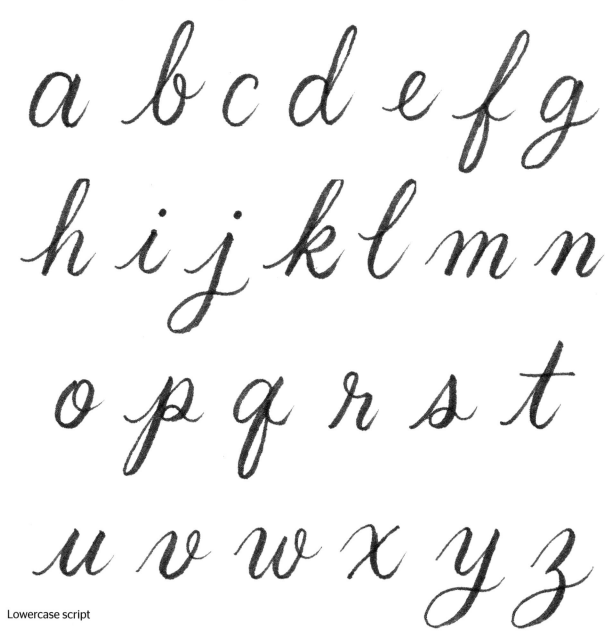

Lowercase script

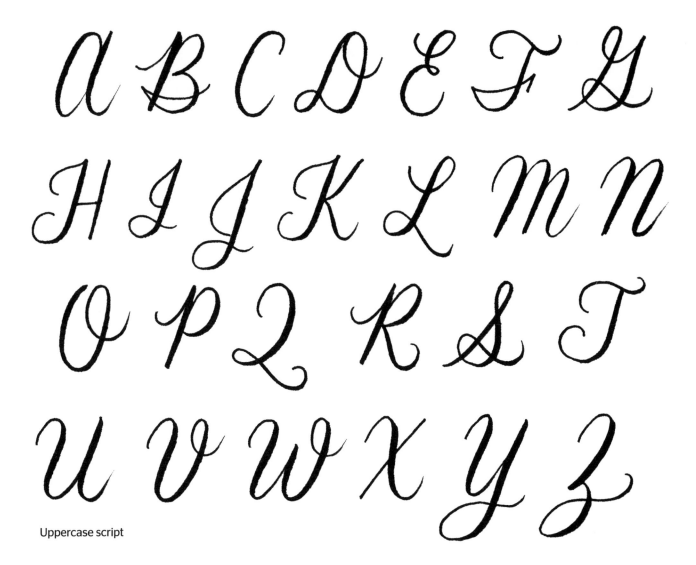

Uppercase script

Connecting Strokes

As you start writing, depending on your letter's orientations and whether you are left or right handed, you may want to keep your paper at a diagonal for easier writing. If you keep your paper straight, make sure your paper is properly marked in order to get a uniform angle measurement once you create your scripts.

Adding Bounce

Bounce lettering adds character to your forms. In school, we were taught to practice handwriting within the lines on our practice sheets. But since hand lettering is all about drawing letters, we can tweak the structures and adjust the letters to our liking. We can opt to disregard the baseline and create our own flow based on the letters that are connected in each word. Instead of just writing each letter in a straight line, the movement of each character on paper integrates into the layout design of each word.

Changing the heights or reducing the sizes of letters in a word makes it easier to build the composition of a quote. There are certain letters, as well, that have qualities suitable for what is called bounce lettering. These letters have distinct characteristics that are best for achieving the bounce effect.

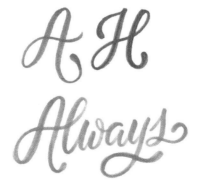

Descenders can be extended and create a bridge to the next letter of the word.

By elongating the letterform's tail or swash of certain letters, the layout can look more put together.

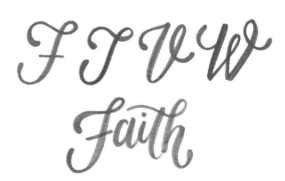

Extending the crossbar on these letters can connect them to the next letter seamlessly.

Adding exaggeration to the top bar helps create a "roof" for the letters inside the word.

Here are some examples of applying the bounce effect to brush lettering.

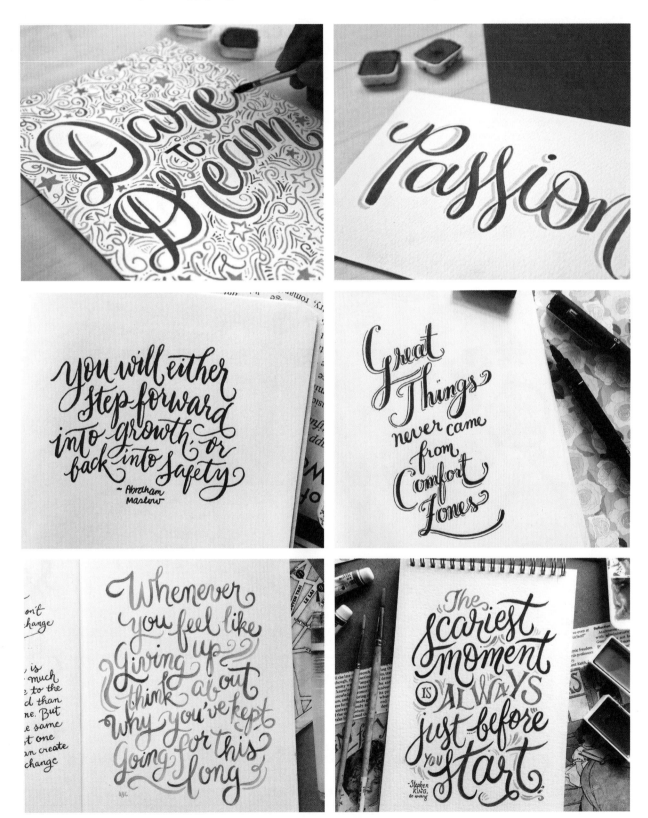

Flourishes

Flourishes add character to your hand-lettering layouts and create a more cohesive look to your design. It is easy to add flourishes to script-style fonts as they are very fluid and connect well.

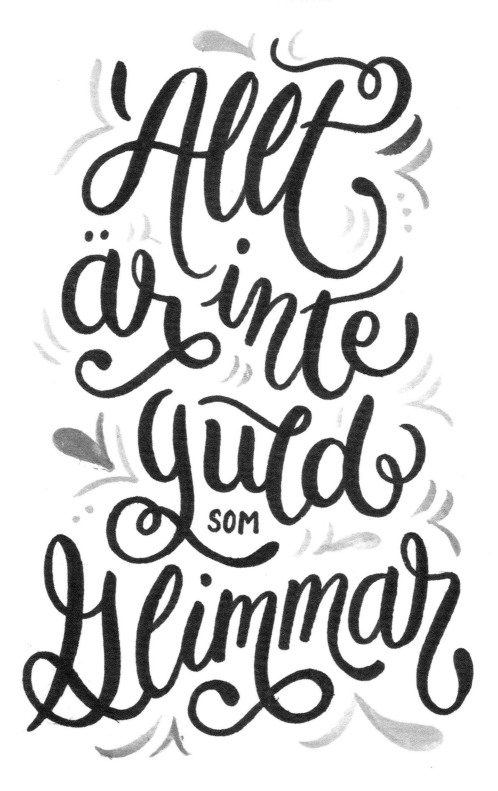

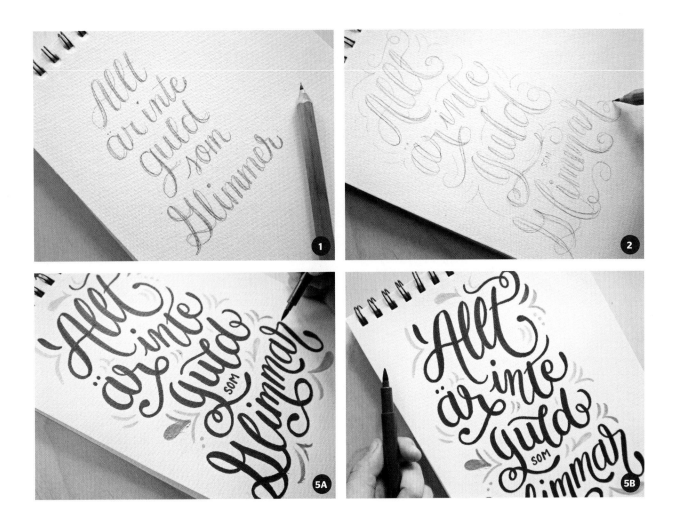

How to Add Flourishes to Your Work

Quote: Allt är inte guld som glimmar. (All that glimmers is not gold.)

1 Start by creating a draft of the quote you will be using.

2 Add bounce, as needed, on a few letters.

3 Find spaces in the layout where flourishes can be added.

4 Experiment with different flourish styles and techniques.

5 Once the layout is seamless, you can start inking it with your brush pen or marker.

Where to Add Flourishes

You can add flourishes anywhere in your hand-lettering work. Use a flourish to create an extra dimension to a word or quote, as the flourish creates a connective line from the letters to its embellished parts in a layout. Flourishing for modern hand lettering has no definite rules. Keep experimenting with different ways to connect each word and/or letterform and find combinations that work for you.

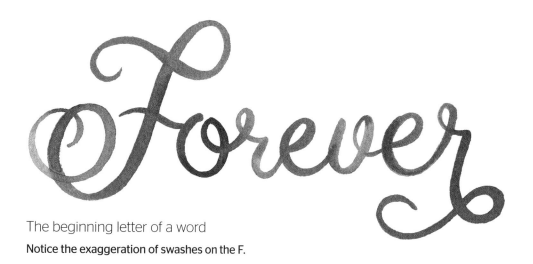

The beginning letter of a word

Notice the exaggeration of swashes on the F.

The middle letter of a word: hanging tail (g, j, r, s, t, or y)

Take note of the integration of words in this layout. Make sure that all words have equal space in the layout.

Beauty

The end letter of a word

The letter Y has a double loop for emphasis.

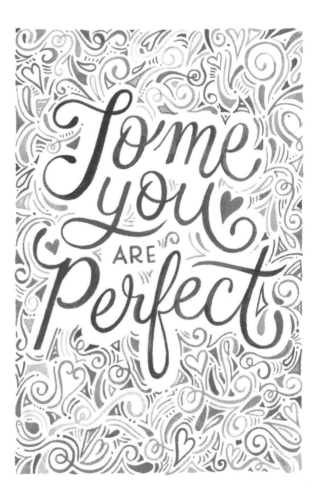

Border-style flourishing

For quotes, choose particular letters that can be flourished and then integrate the flourish with the outside borders for a seamless pattern.

Flowers and Leaves

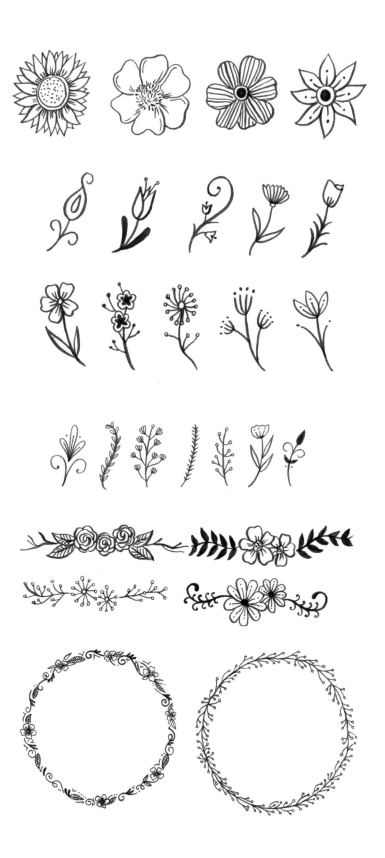

Here are some samples of flowers and leaves that can be incorporated inside letterforms or as additional accents to your layouts.

Enhance your lettering work further by incorporating floral borders or wreaths. These create frames and accentuate the lettered phrase.

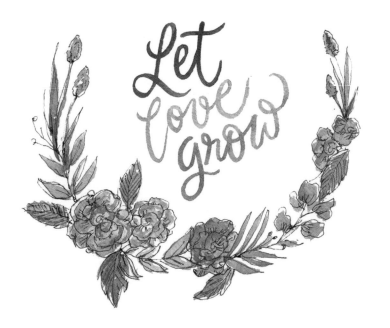

Floral elements are usually applied after the quote has already been lettered. Here are some examples using water-colors. There are many ways to execute this, so keep experimenting until you find a style that works for you.

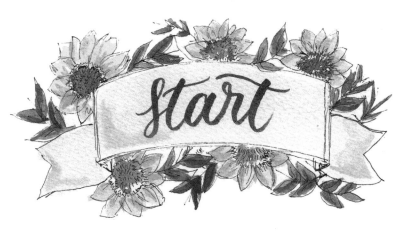

Projects

by Geli Balcruz

TIP

Prepare the plate by washing it in order to help the ink adhere.

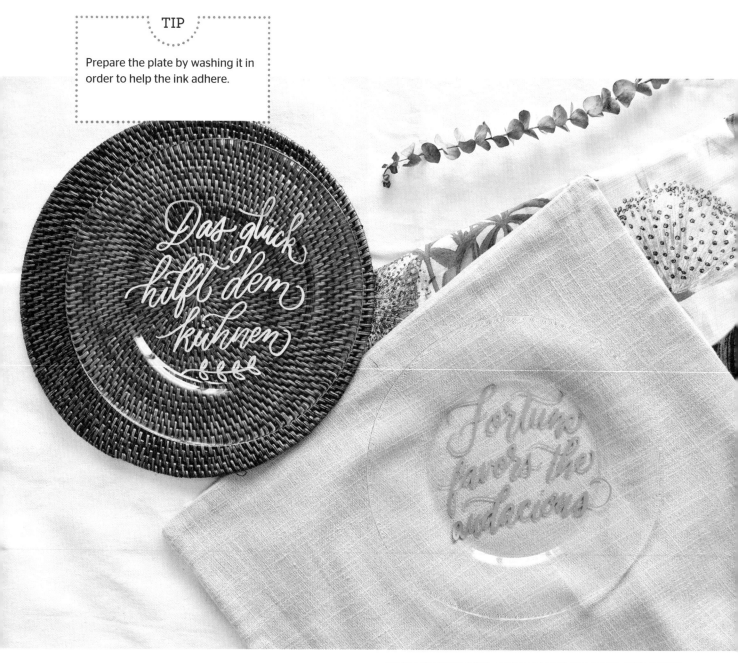

CALLIGRAPHY ON A CERAMIC PLATE

Create a decorative ceramic plate that will add oomph to your table setting or an accent to your wall.

MATERIALS

- ceramic plate
- acrylic marker or acrylic brush pen
- paper
- pencil

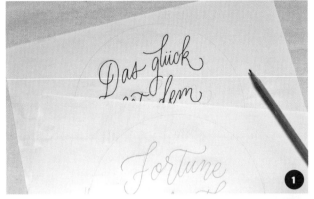

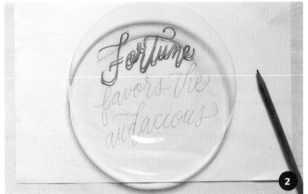

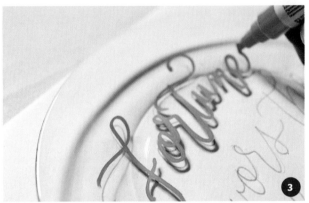

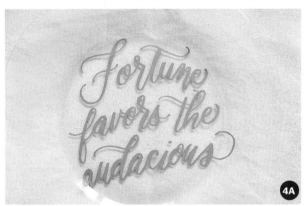

1 Place your plate on a piece of paper and trace around it with your pencil. This will serve as your practice sheet to draft on the word, name, or quote that you'll write on the plate.

2 On your practice paper plate, make drafts of your artwork. You may want to incorporate different styles of calligraphy, especially if you have a long quote to write.

3 When you're done with your drafts, get your acrylic marker or brush pen and start writing on your plate. If you're using a clear ceramic plate, you can place the paper underneath the plate as a guide.

4 Once you're done inking your quote, allow the paint to dry for a few minutes before using it for display. You may apply a protective coating such as a fixative to protect your artwork.

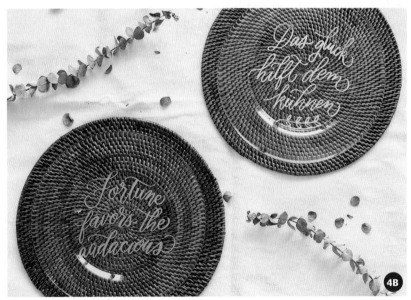

NOTE

This plate is solely for decorative purposes only and not to be used with food.

CALLIGRAPHY ON WOODEN SLAB

These wooden slabs can be a great décor piece or a perfect gift for the holidays.

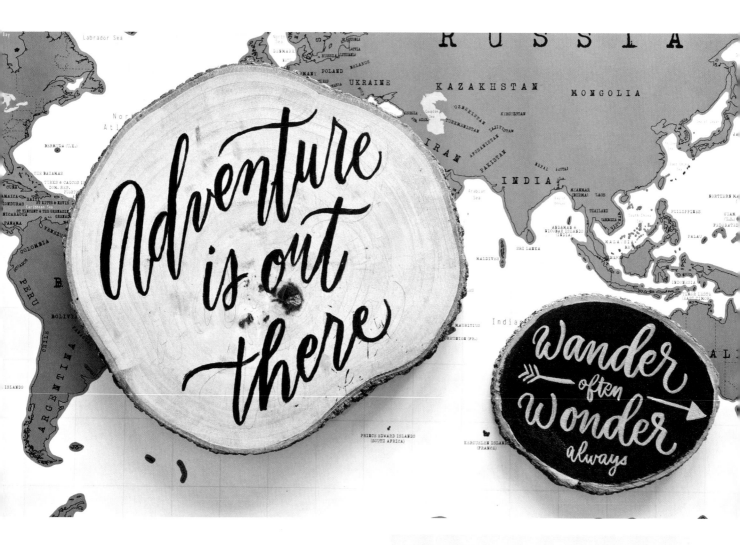

MATERIALS

- wooden slab
- acrylic marker (you may also use a pointed brush and an acrylic color of your choice)
- paper
- pencil

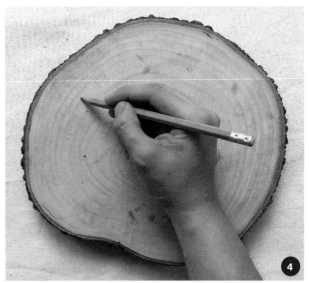

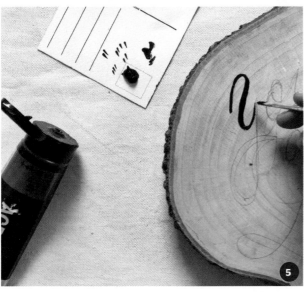

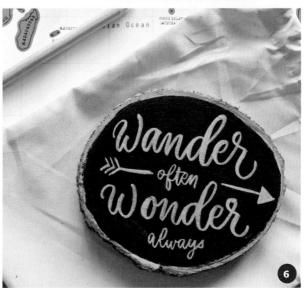

1 Wooden slabs comes in different shapes; you may want to consider the size of the slab when choosing what you'll write on it. Choose a fun word, a motivational quote, a song lyric, etc. This project uses the phrase "Adventure is out there."

2 On your practice paper, create different drafts of your chosen quote. You may want to play around with the layout, calligraphy style, and add illustrations.

3 Once you've chosen your style, decide if you'll paint a background on your wooden slab or opt for single-color paint for your letters.

4 If you're going to paint directly on the wooden slab, lightly write your quote on the wood using pencil. This will give you an overview of your spacing and how the quote will appear. If you decide to paint a background, allow the paint to dry first before writing on top of the surface.

5 Using your marker or a brush and acrylic paint, start inking over the penciled-in quote.

6 Once you're done inking your quote, allow the paint to dry before using it for your parties or décor wall.

Choose notebooks that don't have a glossy cover because the embossing adhesive will not cling to the cover. I've found that kraft notebooks are the perfect fit for this project!

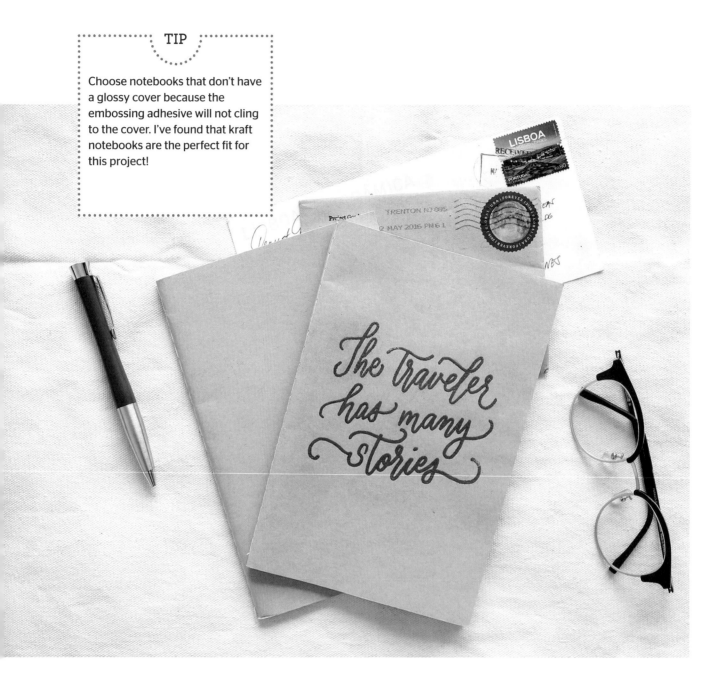

EMBOSSED CALLIGRAPHY NOTEBOOK

Create a one-of-a-kind notebook that will shine. Make one for yourself and a second as a gift for a friend!

MATERIALS

- blank notebook
- embossing pen
- embossing powder
- heat gun
- pencil
- practice paper

1. On your practice paper, start drafting what you'd like to write on your notebook. Have fun making your layout, and don't be afraid to mix different styles.

2. Once you've finalized your quote, pencil in some guides on your notebook or freestyle it and start writing on the cover.

3. Take note of the spaces in between your letters and words as embossing takes a little more space than just writing.

4. Once you're done drafting the quote, get your embossing pen, prepare your embossing powder, and an extra sheet paper.

5. Using your embossing pen, trace over the drafted word and immediately pour the embossing powder. Gently move around the notebook to make sure that you covered the entire area.

6. Shake off the powder onto your extra paper. After you catch the excess powder on your scratch paper, roll it into a funnel to put it back in the embossing powder container so you can reuse it. You can use a small paintbrush or cotton swab to remove excess powder.

7. Hold the embossing gun at an angle at least 4" to 6" (10 to 15 cm) away from the image. Gently sweep the gun over the image and be mindful not to heat one area for too long, as this will burn your paper. The powder will turn shiny and dimensional once the embossing powder melts.

8. Repeat these steps until you embossed over the entire quote.

TIP

When writing a long quote, you may want to emboss it word by word or two or three words at a time to make sure that the embossing adhesive does not dry up on the paper. The paper easily absorbs the adhesive and the embossing powder will not properly adhere if it dries up.

Projects

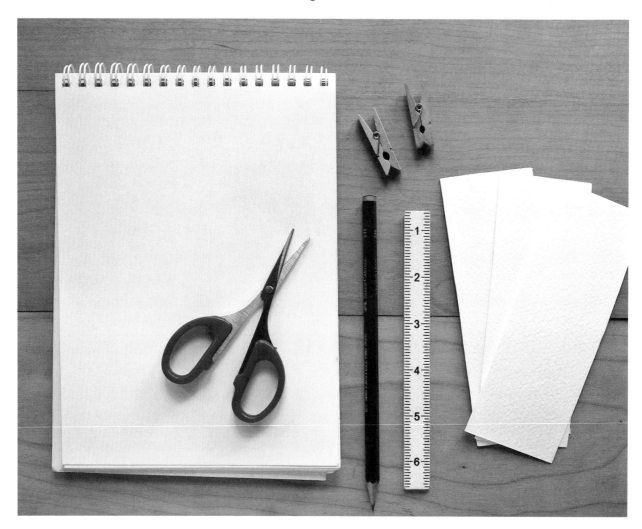

BOOKMARKS

Add a little oomph to your books by designing your own bookmarks with hand-lettered quotes. Plus, these also make great gifts for friends and family!

1 Cut up your watercolor paper to your desired bookmark size. This one is 2" x 6" (5 x 15 cm).

2 Choose a quote you'd like to hand letter on your bookmark. It can be related to the book you're currently reading, or you can make up your own. Make sure it's not too long so it can fit the alloted space.

3 On your scratch paper, do several drafts of the quote you will hand letter. Try applying different layout techniques to achieve the composition that you want.

MATERIALS
- Scissors
- Scratch paper
- Watercolor paper, 300 gsm
- Pencil

There are two styles you can try with your DIY bookmarks:

STYLE ONE: WATERCOLOR WASH

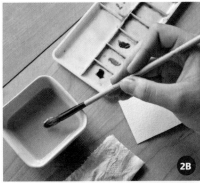

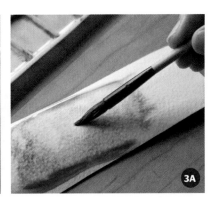

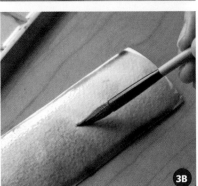

1 Follow steps 1–3 (on page 102).

2 Dip your brush in a watercolor and then in water.

3 With pressure, apply paint using your dipped brush on your watercolor paper. We want to create a watercolor wash background as a base for your lettering. If the pigment is too dark, blot it with tissue paper.

4 Leave it to dry for 30 minutes. Once
(continued)

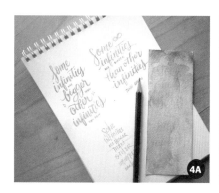

the paint dries, using your pencil, lightly trace your layout design on the watercolor paper. Then using your brush pen, hand letter your quote. Take note of the alignment, depending on word count. Leave it to dry.

> **TIP**
>
> You can integrate two or more colors in your wash as they will blend and have a gradient effect.

STYLE TWO: PATTERN PLAY

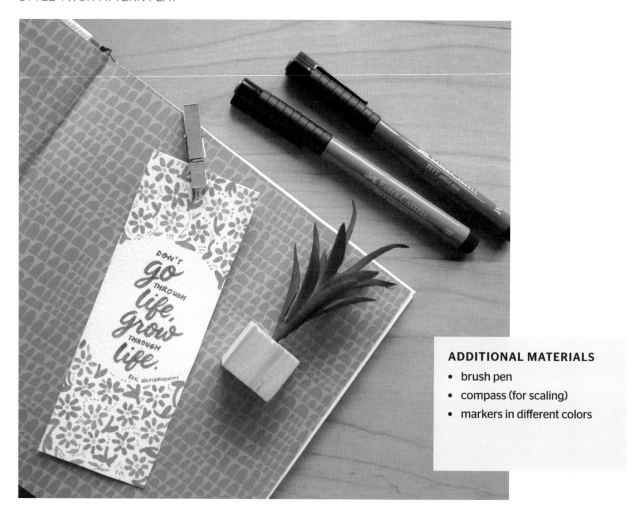

ADDITIONAL MATERIALS

- brush pen
- compass (for scaling)
- markers in different colors

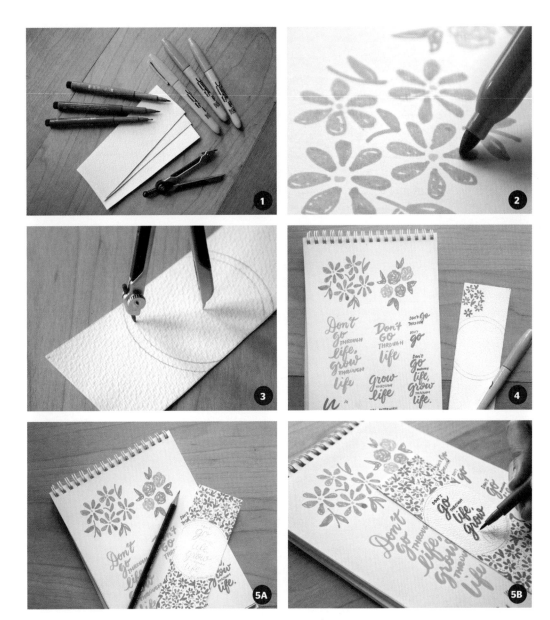

1. Follow steps 1–3 (on page 102).

2. On a separate sheet of paper, experiment with different patterns you'd like for your bookmark.

3. On your watercolor paper, use your compass to draw two circles (one inside and one slightly larger outside) in the middle of the bookmark. This is where your lettered quote will be written.

4. Using markers, create your pattern of choice on the space outside the drawn circle.

5. Once you've finalized your quote design, use your brush pen to write it inside the circle.

HAND-LETTERED COASTER

Place your favorite beverage in a nifty cork coaster.

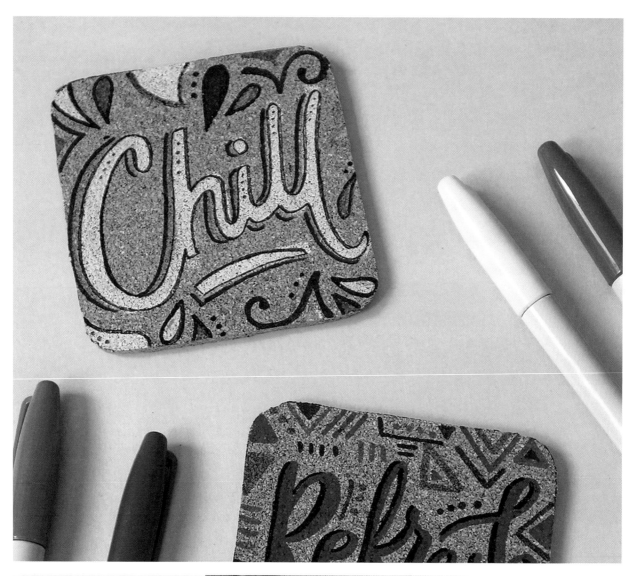

MATERIALS

- pencil
- eraser
- scratch paper
- permanent markers
- corkboard sheet
- scissors/cutter

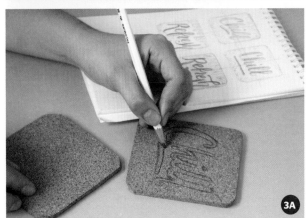

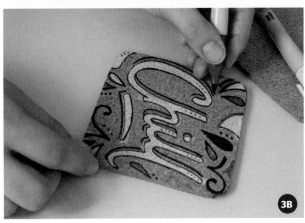

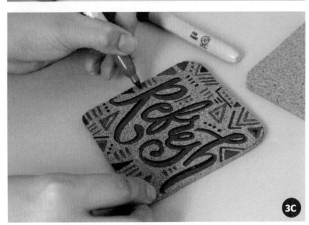

1 On your scratch paper, create various drafts and designs you would like to incorporate into your coaster. I'm keeping it simple with some one-liners and basic patterns.

2 Using your ruler, measure your preferred coaster size. Mark the dimensions on the corkboard sheet and cut accordingly.

3 Once the cork sheet has been cut into squares, pencil in rough guides on your coaster. Then, using your marker, color it in.

4 Leave them out to dry before using.

WALL ART

Be inspired to take on adventures with this travel-themed wall art that you can display in any room.

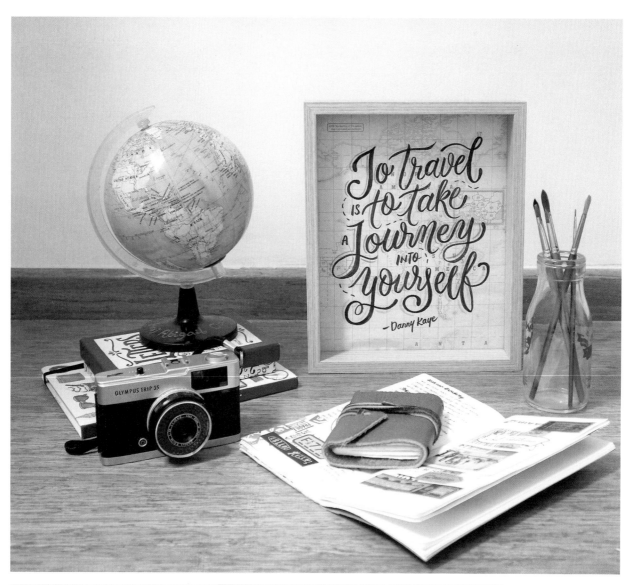

MATERIALS

- pencil
- eraser
- ruler
- scratch paper
- world map (or any map of your choice; must be writeable)
- permanent brush marker
- wooden frame

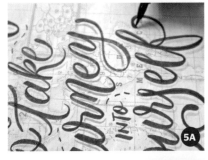

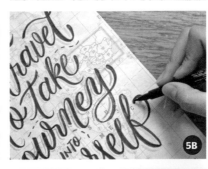

1. On your scratch paper, create various layouts of your chosen quote. Make sure that the word count fits the canvas.

2. Cut your map to fit within the the wooden frame. I'm using a letter-size frame (8.5" × 11" or A4), so I will cut up the map to that size.

3. Prepare your map by measuring out 1" (2.5 cm) borders on all sides and creating a division at the center using your pencil.

4. From your set of layout drafts, choose your best layout and transfer it onto the map. Lightly trace it with your pencil to use as guide for inking.

5. Using your brush marker, trace over the pencil marks.

6. After adding lettering on the map, leave it to dry for 1 hour. Once it is dry, erase the visible pencil marks and affix the wooden frame. It's now ready for display.

Decorative Lettering

The history of decorative lettering traces back to drop caps or initials, which were used as the first letter in the introductory paragraph of a book or publication. Appearing as early as the fourth century CE, they reached their peak popularity in the fifteenth century. These letters had distinctive chracters and illustrated patterns as part of their design, and doubled as art. However, over the years, artists and designers have incorporated drop caps into their respective work, derived from their personal styles—bringing it back as a fundamental aspect of modern hand lettering.

Decorative lettering is formed by adding ornaments to specific areas of each letterform. And because the goal of hand lettering is to turn letters into visual art, the alphabet is enhanced through decorative elements added to the layout. By using different weights of a fineliner pen and utilizing colors from watercolors or markers, each style can come out in different forms.

In this chapter, we will learn about both serif and sans serif styles, as well as how to create illustrations within letterforms. Creating layouts is a crucial part of hand lettering, as it helps set the legibility and appearance of the work you make. In the next few pages, you will find the step-by-step process of building a hand-lettered layout—from drafting to experimenting with font to the final application on your chosen canvas.

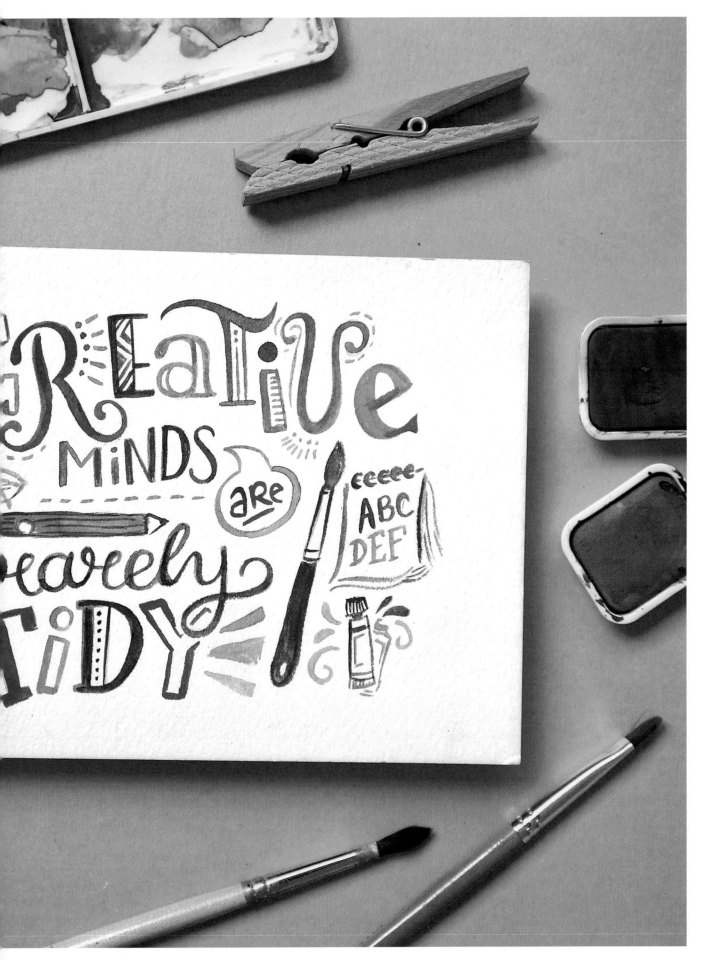

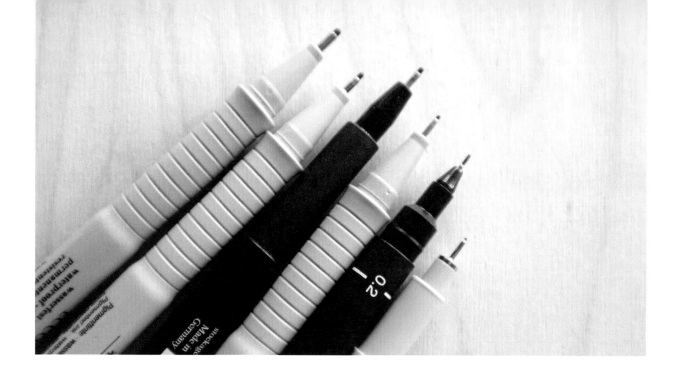

Using Liners

The most common type of pen used for decorative lettering is the fineliner pen or technical pen. This pen is best used on paper, and usually comes with a round tip. Most fineliner pens come in varying widths—from 0.05 to 1.0 mm—depending on the purpose (see page 113).

Fineliner pens are meant for drawing, not writing. Ink is usually waterproof as well, making it easy to add a layer of color after completing the letter's line art. Although, depending on the artist's preferences, the details can be outlined after the paint or marker color has been applied to the paper.

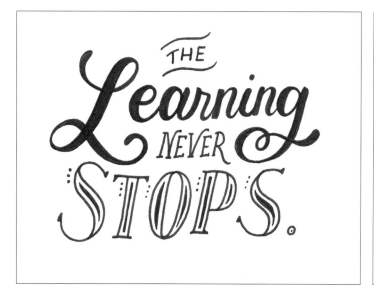

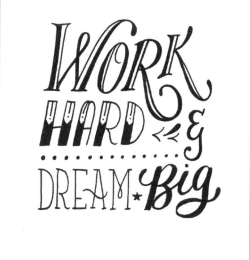

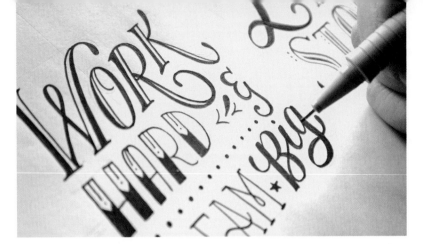

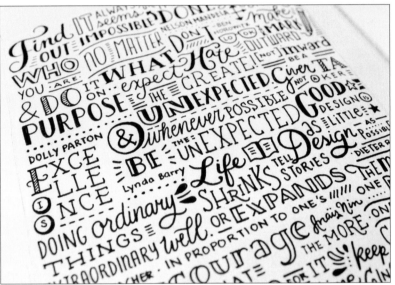

Holding the Pen

The proper way of handling a fineliner pen is similar to how you handle a pencil or any basic writing tool—using your thumb, index finger, and middle finger. Hold the pen firmly, but not too hard, to avoid cramping. Also, make sure you have enough space to draw.

Thick vs. Thin Weights

Thick fineliner pens (0.5 to 1.0 mm) are used for coloring or filling in areas or for illustrating bold outlines of the letterforms. Thin fineliner pens (0.05 to 0.4 mm) are used for intricate details either inside or outside the letterform, depending on the patterns incorporated in the design. It's recommended to have both thick and thin fineliner pens in your arsenal as they are both necessary for hand lettering.

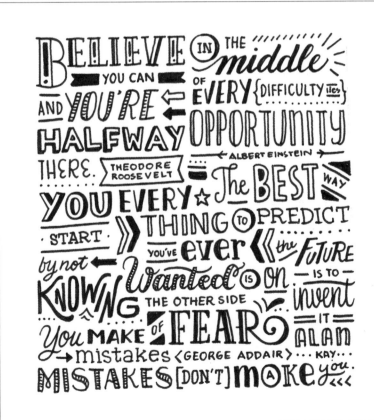

Serif

A serif font contains extending features at the end of each letter. Mostly used for body text, as it enables readability, this font style is more traditional in terms of aesthetics. Serif styles were the first font style developed in the early eighteenth century.

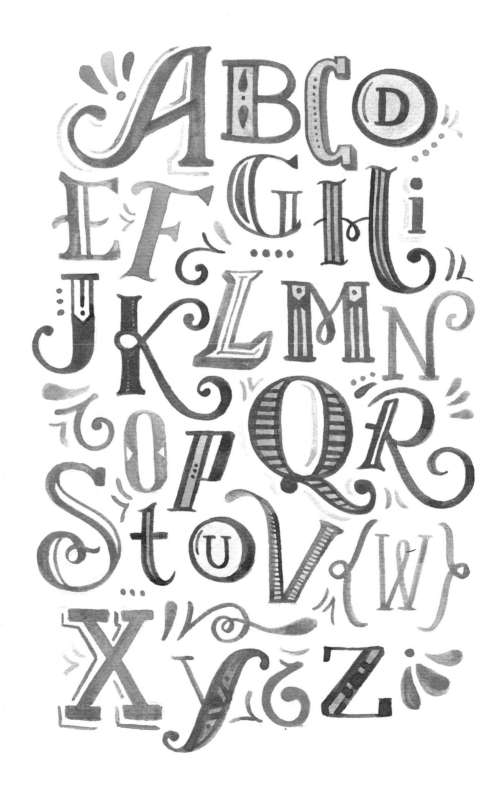

Old Style

Old Style

Old style serif letterforms are bracketed and there is only a little weight contrast between thick and thin strokes. This is an ideal serif style for textbooks and other reading material.

Transitional

Transitional Serifs

A reinvention of old style serifs, the typefaces in this category represent the transition from old style to neoclassical style of serifs. Transitional serifs' weight contrast is more prominent than their predecessor, and its serifs are still bracketed.

Neoclassical

Neoclassical/Didone Serifs

Created in the late eighteenth century, this serif style has a high contrast between thick and thin strokes, and there is little to no bracketing for its serifs. Its stroke terminals are ball or round shaped, compared to other serif fonts, which are inclined to the left.

SLAB

Slab Serifs

This type is characterized by having low contrast in terms of letterform thickness and its terminals can be rounded or square. Slab serifs are naturally bold and heavy, and are commonly used for advertisements or headlines.

Sans Serif

A sans serif font does not have extending features, or serifs, in its letterform style (*sans* means "without" in French). Commonly used for headlines and bold announcements, this font style evokes a simple and modern aesthetic.

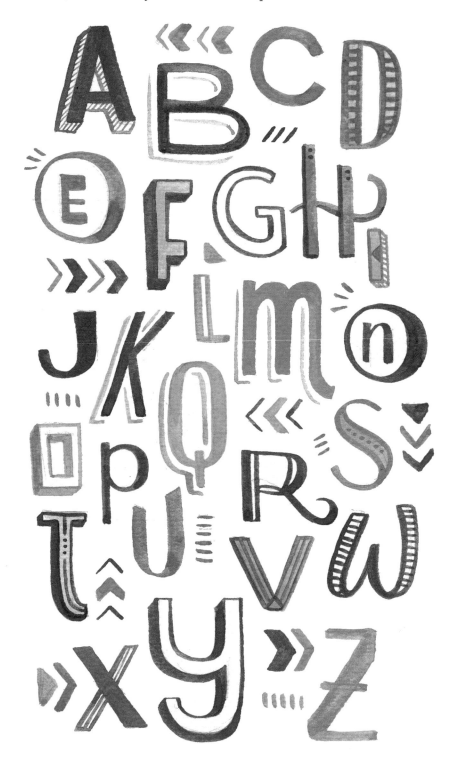

Grotesque

Grotesque Sans Serif

The first commercial sans serif font, this style has the most prominent contrast in stroke weight and has the distinctive bowl-and-loop lowercase g for its type.

SQUARE

Square Sans Serif

A sans serif type that has a definite squarish curve to its strokes, square sans serif fonts have more character spacing than other sans serif fonts.

Geometric

Geometric Sans Serif

Inspired by geometric shapes and figures, its strokes have strict monolines and, overall, this letterform is harder to read than grotesque styles.

Humanistic

Humanistic Sans Serif

These letterforms have a strong calligraphic influence, and their contrast is comparable to old style serifs.

Letters and Layouts

While it's important to put together the letterforms and create different font styles in the process, the heart of lettering lies in the layout, as you combine words to form a cohesive structure.

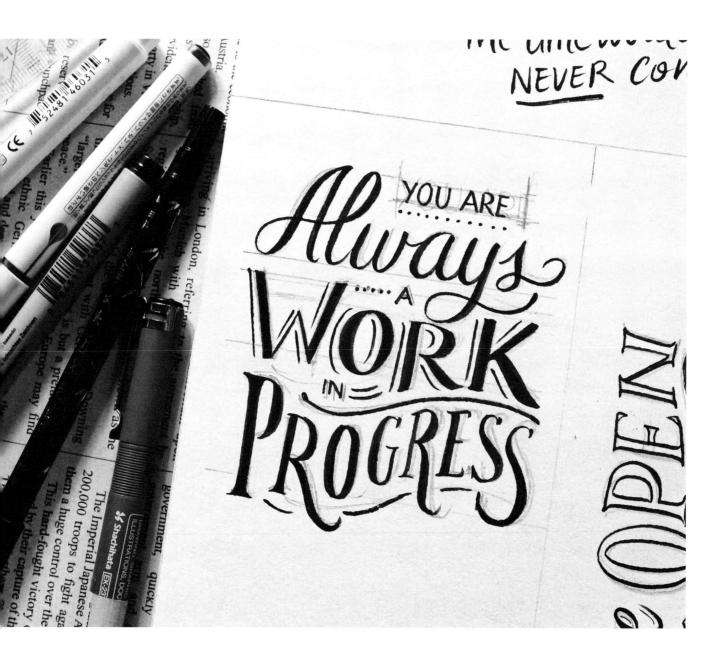

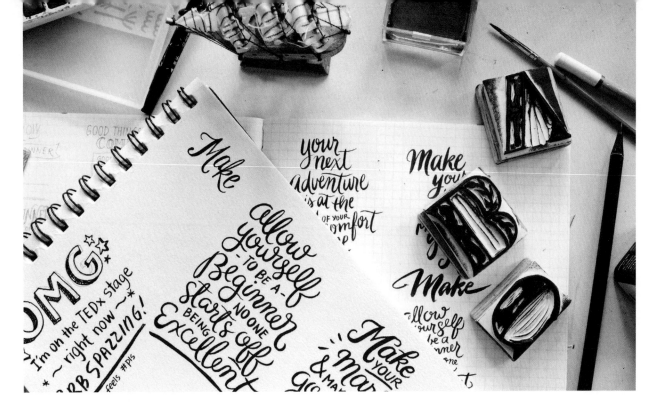

There are a few key things to remember when it comes to making layouts.

Inspiration

From movie posters, product packaging, to vintage type books—inspiration is everywhere. Expose yourself to different type work, choose ones you like the most, and try to add your own twist to them.

Grouping

Most quotes have many words; and it's important to group them together and create a hierarchy of sorts to assign the corresponding sizes and widths per word.

Layout Alignment

Do you want your quote aligned to the left, right, or center? Be sure to allot enough space depending on the layout alignment of the quote you are going to hand letter.

Word Count

A quick tip for beginners: the fewer, the better. Keeping track of word count (and letter count per word) is crucial in order to the plot the layout properly. Keep in mind that word count helps determine the overall layout of your work and the corresponding font styles that can be used, given how many words your quote has.

Spelling and Grammar

Always a necessary part of making layouts— double-check your spelling and grammar before beginning your lettering and layouts.

Neatness and Proper Spacing

Along with plotting your layout in a structured and organized manner, it's important for there to be proper spacing for words to "breathe" on paper. Allow for white space and enough room for the layout to look cohesive but still be readable by the viewer.

Creating a Layout

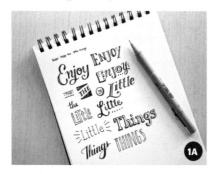

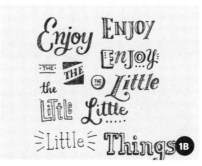

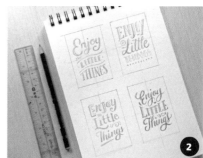

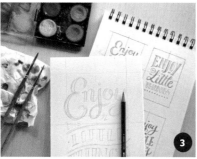

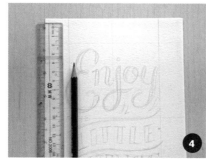

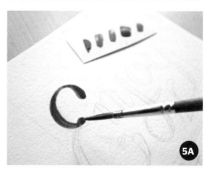

1 Compile and curate

From the quote you've selected, create a library of font options in different styles (serif, sans serif, and script). Having this database of font samples can give you a clearer overview in terms of which styles you want to focus on and what font types best suit the words you will letter.

Get creative! Use different font styles and work with the varying structures of words and letters. Choosing and combining font styles are key in coming up with a good layout.

2 Collect and select

Gather a few of your chosen font styles and combine them together in a layout. I like to come up with two to four layouts in thumbnails to experiment and exercise my skills in putting words together. Note that we are still doing the drafts at this point.

Keep experimenting and working on your layouts in order to figure out which ones work best for your quote. Also, at this point, think of integrating possible embellishments within the layout.

3 Choose and combine

Choose one final layout from your thumbnail studies. From there, work on your sample and think of possible color schemes you will use.

TIP

Make sure to choose at least three to five colors within the same family to ensure that the layout is neat and cohesive.

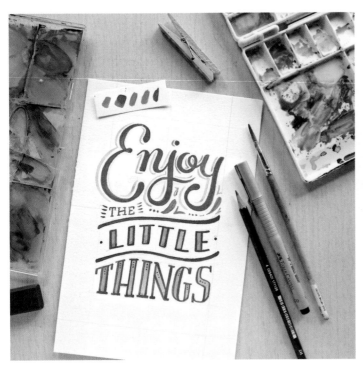

4 Transfer and proportion

Once your design, color scheme, and layout are finalized, transfer it to your main canvas. Make sure to proportion it properly by creating grid guides so that the work is well balanced.

It's recommended to start your layout in the center, and allow at least 1" (2.5 cm) of white space from all four corners of your paper. This helps create the proper alignment of your work.

5 Create and color

On your final sheet, start filling in your layout with color and add embellishments to your liking. Make sure to keep measurements in check and to maintain cleanliness while working on your piece!

Remember that it takes a lot of practice to make your work look great, but it's always possible if you trust the process and keep working toward improving your illustrations and layouts.

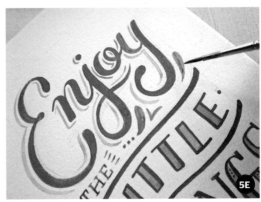

Creating Illustrations within Letterforms

Letters are naturally plain; and through decorative lettering, they become more visually appealing. The open areas of each letter are places to get creative and add illustrations to enhance the artwork. Here are some samples for you to try.

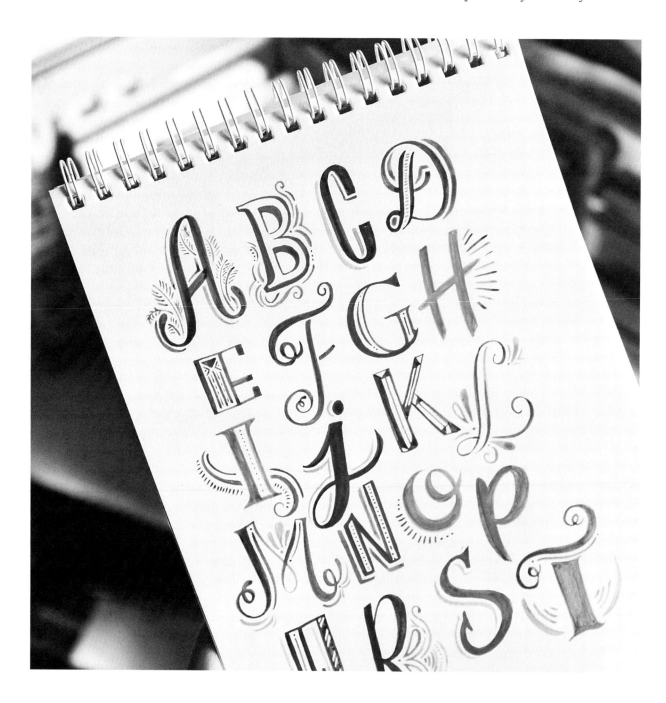

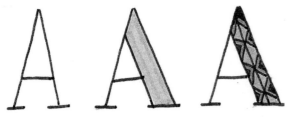

Lined pattern (basic linear shapes and patterns)

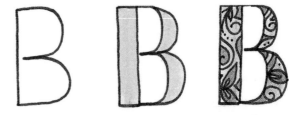

Elemental pattern (complex, connected patterns)

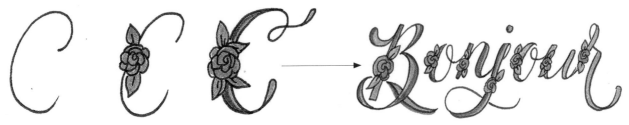

Embellished (botanical accent on a certain area of the letter)

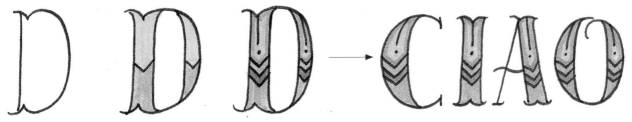

50/50 (two different patterns on both sides of the letterform)

3D style (retro effect created by adding inlines and exaggerated shadows)

Conceptual (illustrative)

Projects

DROP-CAP TOTE

Decorate your tote bag with a drop cap initial of your name.

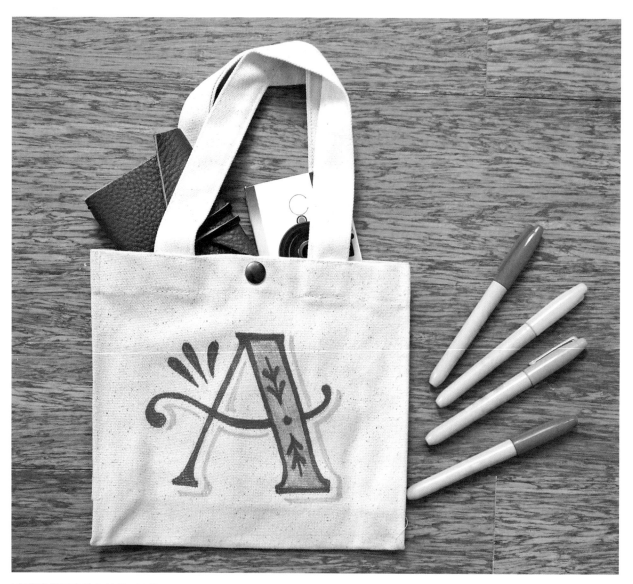

MATERIALS

- pencil
- eraser
- ruler
- scratch paper
- permanent markers (in various colors)
- plain canvas tote bag

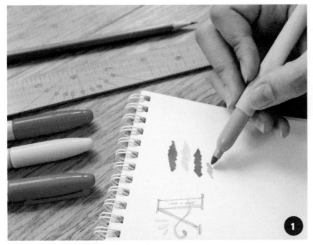

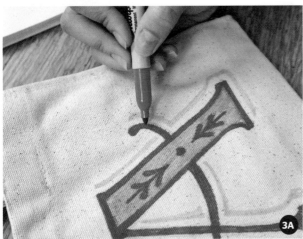

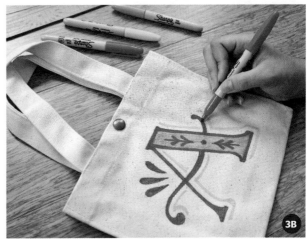

1 On your scratch paper, choose your drop-cap initial and work on your designs. Make sure to refine the strokes and plot out an ideal color palette as well.

2 Once you've chosen your final design, use your pencil to lightly draw the letter's structure at the center of the canvas tote bag. Use your ruler if you need to measure out the sizing.

3 Using your permanent markers, color in the drop-cap design on the tote bag. Start by filling in the large areas, and, finally, add the patterns and embellishments.

4 Let dry before using.

PHONE CASE

Personalize your phone case with a hand-lettered quote.

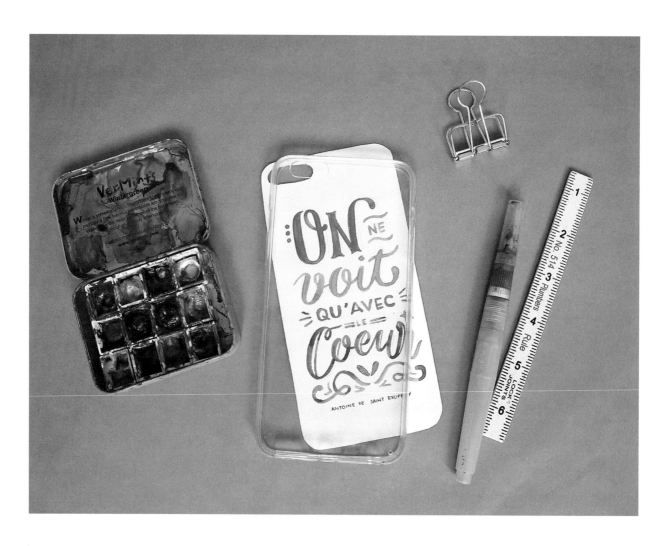

MATERIALS

- pencil
- eraser
- ruler
- scratch paper
- scissors
- watercolor paper
- watercolors
- paintbrush
- clear cell phone case

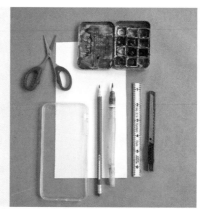

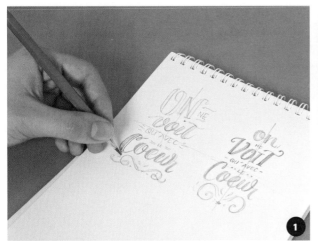

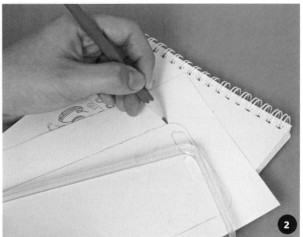

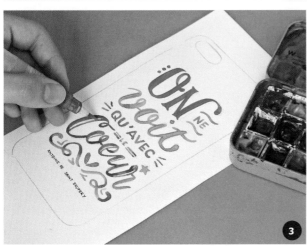

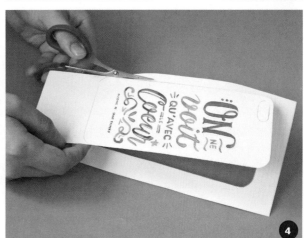

1 On your scratch paper, create drafts from the quote(s) you've chosen.

2 Trace the shape of the phone case on the watercolor paper.

3 Using your pencil, illustrate your layout on the watercolor paper, then paint it with your watercolors.

4 Leave it out to dry. Once it's dry, Cut out the shape and insert it in your clear cell phone case.

PATTERNED NOTEBOOK COVER

Add some character to a plain notebook by decorating its cover with pattern-style lettering.

MATERIALS
- pencil
- eraser
- ruler
- scratch paper
- fineliner pen
- black (or other color) notebook

1 On your scratch paper, sketch a few quotes that you would like to use for the pattern on your notebook cover. Do a couple of drafts and studies before settling for your final design.

2 Pick out specific font styles and layouts you would like to use for the cover pattern. I'll be using both serif and sans serif in block styles and thin styles for this example.

3 On your notebook cover, lightly measure out areas where the quotes will be placed in pencil. This is optional, as most of the time, I draw straight on the cover without any guides.

4 Using your fineliner pen, start illustrating quote on the cover. If there are extra spaces, fill them up with dotted lines or dividers.

5 While filling in the cover with lettering, make sure that there is empty space in the layouts to avoid making it too cluttered.

6 Once you've finished lettering the cover, leave it out to dry for a few hours. Then, you're ready to start using your notebook!

Digital Lettering

Risa Rodil

Lettering is everywhere—in billboards, in TV commercials, in film, in product packaging, and even in brand logos. As technology continues to evolve, artists continue to discover new tools and methods to reinvent the way they approach lettering. The ability to digitize your work enables you to transform your pieces into various types of media—in print, on shirts, or animated.

Digital lettering allows you to manipulate your shapes and letters and resize them however many times without losing quality. It's also a fast way to do revisions, align letters, and change colors. With so many tools you can access in a few clicks, the possibilities are limitless.

Different artists have their own set of tricks and techniques at their disposal, and the process I will be sharing here is just one of many. Some artists start on paper, scan their work, and trace them in a digital program of their choice, while others prefer to do all the work on the computer. Hopefully, by the end of this chapter, you will find the method that works best for you.

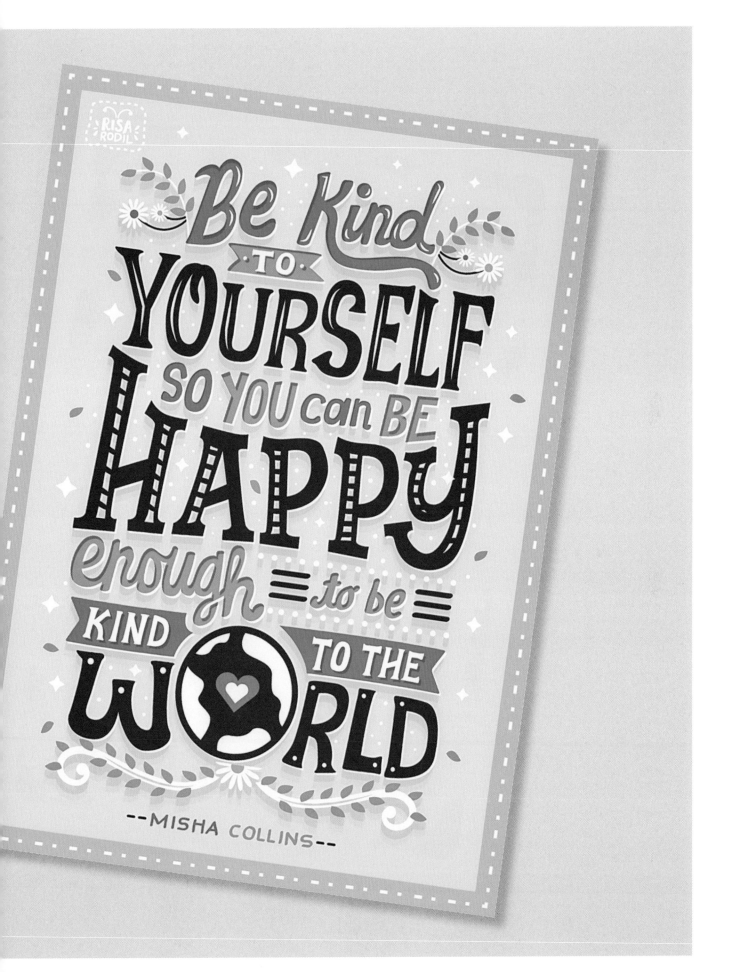

Getting Started

To start off, make sure you have your traditional and digital tools ready. It's recommended to sketch out your ideas on paper, first, before transitioning to a fully digital rendering of your work. This helps build a foundation for your project.

Digital lettering is all about translating your ideas on a digital platform, and it is recommended to do research on different techniques and styles you would like to achieve with the work you will be doing. What's great about the abundance of software is that there is more room to experiment and try out ways to create your works digitally.

Tools

Scanner

A scanner comes in handy for letterers who prefer to build their layouts on paper and then scan them in for digital tracing.

Laptop or Desktop Computer

Any computer that can run a design program will work.

Digital Program

I highly recommend using Adobe Illustrator because it lets you work in vectors, which are based on geometrical paths rather than pixels.
This means your shapes and brush strokes will retain their quality even if you scale them to the biggest size possible.

Graphics Tablet

The main advantage of using a tablet is its touch screen can mimic paper. This allows you to make your brush strokes look more natural and free flowing on the screen.

Printer

Any home printer will work for DIY projects. Bigger projects and projects using surfaces other than paper might require a specialty printer.

Scanning and Basic Editing

1 Once you've finalized your sketches, scan them to your computer. If you don't have a scanner, taking a photo with your phone camera will do, as long as your sketch is still recognizable.

2 After scanning, open the image in Illustrator then position it in the center of your art board. Place it in the bottom layer, lower the opacity, and lock the layer. This sketch will be your rough guide as you start digitizing the letterforms.

All in good time.

............... TIP

For letterers who make their sketches as refined and as close to final as possible, a neat trick to instantly vectorize your sketches is to use the image trace feature in Illustrator.

To achieve accurate results, make sure to neatly ink your sketches, erase the pencil markings, and scan it at 300 dots per inch (dpi) or above. Inside the Image Trace Panel (Menu > Window >Image Trace), click Trace, then feel free to play around with the values until you reach the cleanest result, then click Expand. From there, it's just a matter of assigning colors to your vectorized letters and adding final touches, as you see fit.

Drawing Letterforms

There are various ways of shaping and building your letters in Illustrator. The key is to explore and experiment until you find the tool(s) that you're most comfortable with. After years of using the program, the top three tools that have always given me the best and accurate results are as follows.

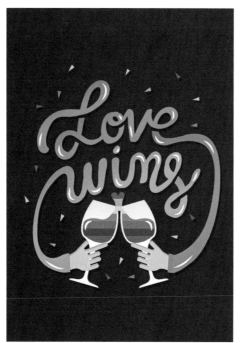

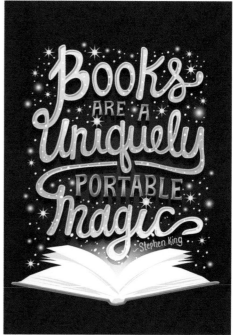

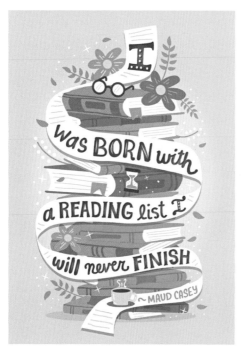

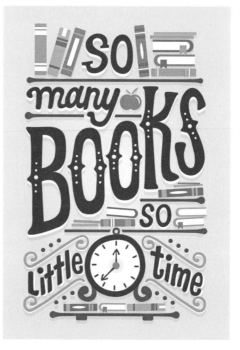

Pen Tool

This tool lets you create crisp lines and pixel-perfect curves and shapes. It can be a bit intimidating at first, but as with anything, practice makes perfect. And once you master the ins and outs of this tool, you can create any letterform with precision.

The pen tool is a popular choice for many because it offers the option to work with editable paths—these are outlines of your vector shapes, which are made up of anchor points. You can easily tweak each of these points to reshape the lines and curves to your liking.

To trace your sketched letterforms, click and create anchor points around each letter until you achieve the right shape. Click and drag your pointer to make curves. Close the path by clicking the first anchor point, then repeat the process for each letter.

TIP

Hold down the shift key to constrain the angles.

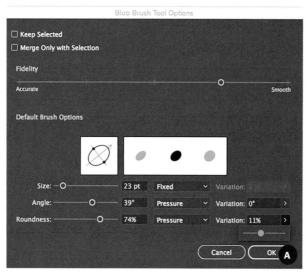

Blob Brush Tool

For smoother and more natural-looking letters, I recommend using the brush tool. This tool works best with a graphics tablet, mostly to achieve clean script and cursive styles. To create smooth brush strokes, play around with the values inside the brush tool options (to open, click the Blob Brush Tool icon in the tools panel) (A), (B), and (C).

Basic Shapes

Another effective way to draw your letters is through basic shapes. This tool is especially helpful for artists who have a hard time drawing perfect lines and curves. With basic shapes, you can easily create perfect circles for difficult and curvy letters (D).

Creating Special Effects

One thing that sets digital lettering apart from using pre-existing fonts is you can get as playful and creative as you like. This is what makes lettering fun; you can make your own styles. Here are some of the special effects I like to add to my letters.

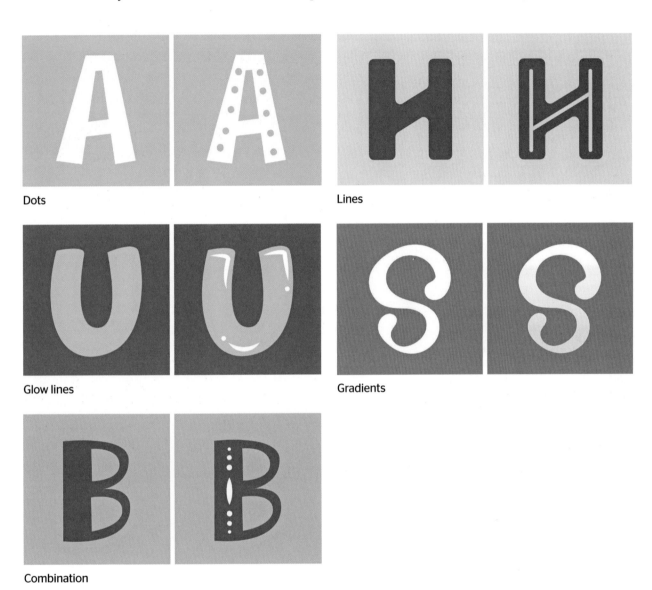

Dots

Lines

Glow lines

Gradients

Combination

Expressive/Descriptive Lettering

Another cool trick you can try is to take the literal meaning of the word(s) and use that to illustrate the letters in a fun way.

 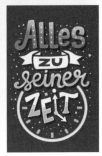

Mixing Colors

Colors play a huge role in bringing your designs to life. Artists use them to evoke the overall mood of the piece, to deliver a message, or to simply create an eye-catching piece. Here's how I usually mix my colors inside Illustrator:

1 Open the Swatches panel (Menu > Window > Swatches) and click New Swatch.

2 Under Document Color Mode, click CMYK. I find it easier to mix colors using CMYK, but other artists prefer the other color modes. Feel free to experiment.

3 It's trial and error from here. Play around with the values until you find the right color you're looking for.

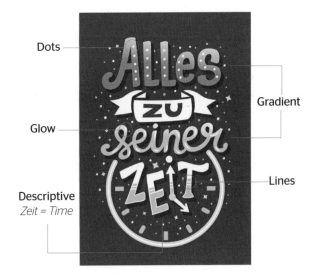

Dots

Glow

Descriptive
Zeit = Time

Gradient

Lines

Adding Dimension

A three-dimensional effect can be achieved by simply adding amplified drop shadows and bevels to each letter. These effects can make specific words stand out or add depth to your main artwork. This helps give the illusion of the words popping out from the page.

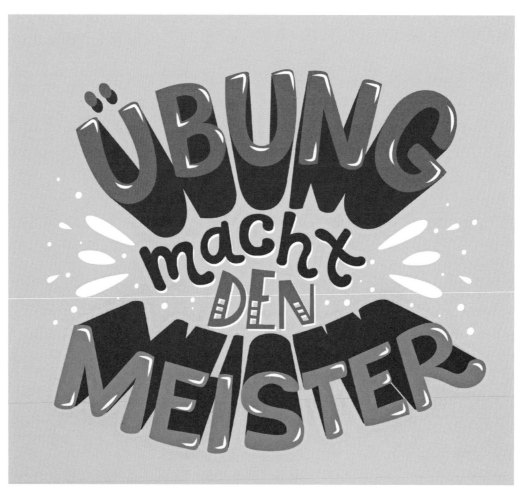

Practice makes perfect.

One way to add dimensions is by duplicating the letters backward and resizing them down one or two point sizes.

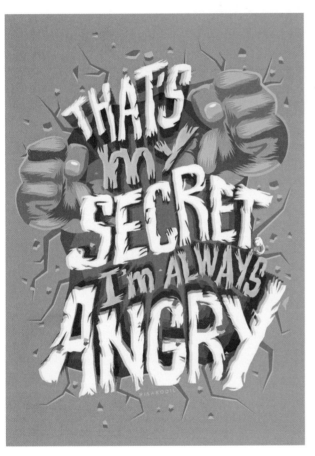

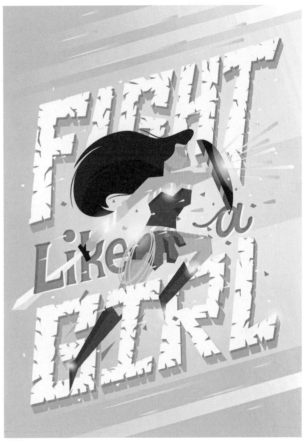

Projects
by Christine Herrin

INSPIRATIONAL PRINT SET

Spread your favorite lettered quotes by making printable sets to share and swap.

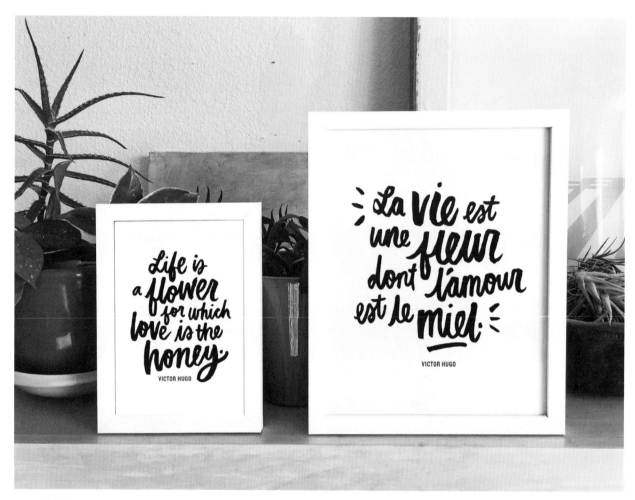

MATERIALS

- 8.5" × 11" (A4) card stock
- practice paper
- brush pens
- camera or scanner
- Adobe Illustrator
- Adobe Photoshop
- printer

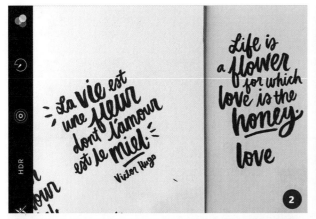

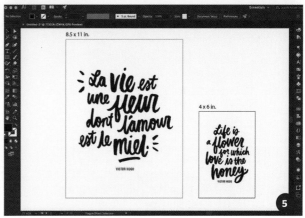

1 Letter out an inspirational quote on practice paper. You can start out practicing the design with pencil before inking your final quote with brush pens.

2 Bring your lettering onto the computer via a photo or scan. If you are using a scanner, scan your sheet of practice paper. If you are using a camera, make sure that the photo you are taking of your practice paper is bright, straight, and in focus.

3 Save your scanned image or photo on your computer. Open your image in Adobe Photoshop to increase the contrast. Adjust brightness and contrast levels to make sure your lettering is clear.

4 Open your edited image in Adobe Illustrator. To turn your lettering into a vector file, open the image trace toolbar at Window > Image Trace. With your image selected, open the toolbar. Select the ignore white checkbox under Advanced, and click Trace. Click Expand under the top toolbar. If you are converting multiple pieces at the same time, right-click on the selection and select ungroup.

5 Create two Artboards: one sized 4" × 6" (10 × 15 cm), and another sized 8.5" × 11" (22 × 28 cm).

6 Scale your lettering to fit the different-sized Artboards. For easy printing purposes, create a new 8.5" × 11" (22 × 28 cm) artboard and include two 4" × 6" (10 × 15 cm) prints inside.

7 Print out the different-sized quotes. Cut the two 4" × 6" (10 × 15 cm) prints and share!

GIFT WRAP

Creating your own gift wrapping paper is easy and adds a special personal touch to all your presents.

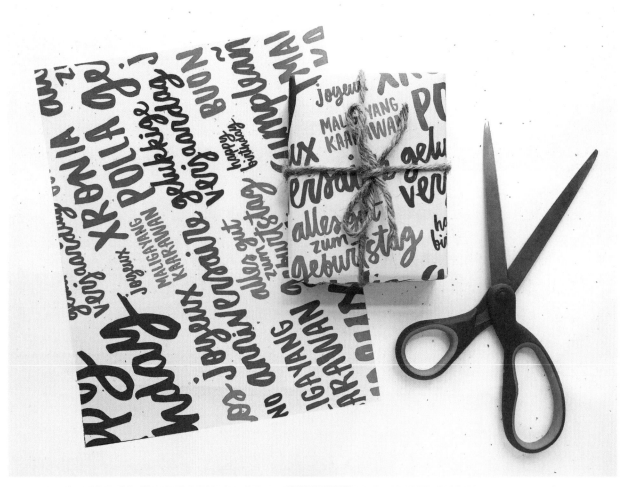

MATERIALS

- kraft or colored paper (size depends on how big your gift is; the example in this project is 8.5" × 11" [22 × 28 cm])
- practice paper
- brush pens
- camera or scanner
- Adobe Illustrator
- Adobe Photoshop
- printer

1 On your sheet of practice paper, use your brush pens to letter phrases and doodles for your gift wrap. Don't worry about arrangement or layout yet, just get all the elements you want to include down on paper. For our example, we used several different ways you can say happy birthday, but you can letter out phrases depending on the occasion you're celebrating.

2 Bring your lettering onto the computer via a photo or scan. If you are using a scanner, scan your sheet of practice paper. If you are using a camera, make sure that the photo you are taking of your practice paper is bright, straight, and in focus.

3 Save your scanned image or photo on your computer. Open your image in Adobe Photoshop to increase the contrast. Adjust brightness and contrast levels to make sure your lettering is clear.

4 Open your edited image in Adobe Illustrator. To turn your lettering into a vector file, open the image trace toolbar at Window > Image Trace. With your image selected, open the toolbar. Select the ignore white checkbox under Advanced, and click Trace. Click Expand under the top toolbar. If you are converting multiple pieces at the same time, right-click on the selection and select Ungroup. Each phrase should now be movable and scalable.

5 Lay out the different phrases as a pattern on your artboard. Make sure to vary the sizes (and even colors!) of your phrases to create a fun pattern.

6 Print out your design on a sheet of kraft or colored paper. Wrap your gift and make sure to top it off with fun accents like washi tape or a personalized note on top!

JOURNALING CARDS

Use lettering to design your own journaling card templates for scrapbooking and other journal projects.

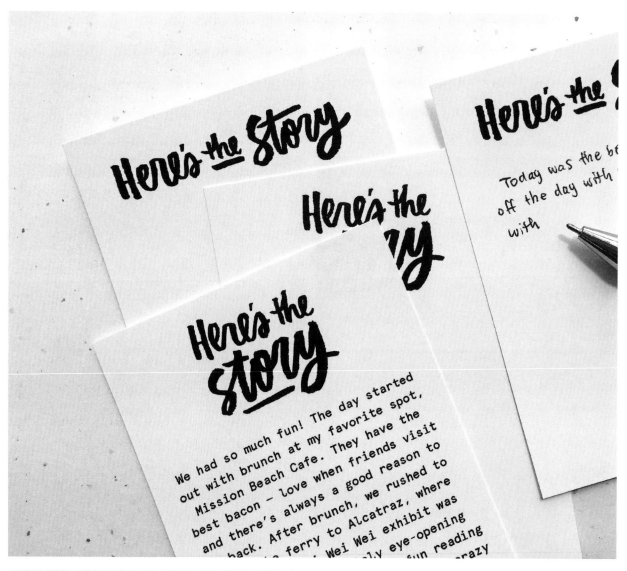

MATERIALS

- practice paper
- brush pens
- camera or scanner
- Adobe Illustrator
- Adobe Photoshop
- printer
- 8.5" × 11" (A4) card stock

1 Letter out a phrase on practice paper. For journaling cards, the more general the phrase, the better, since you're creating templates for future use. For this project, we're using the phrase, "Here's the Story" — for you to fill in stories in the future!

2 Bring your lettering onto the computer via a photo or scan. If you are using a scanner, scan your sheet of practice paper. If you are using a camera, make sure that the photo you are taking of your practice paper is bright, straight, and in focus.

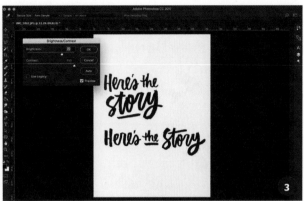

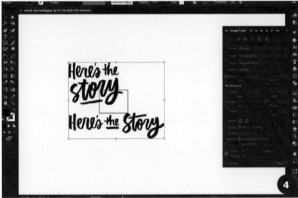

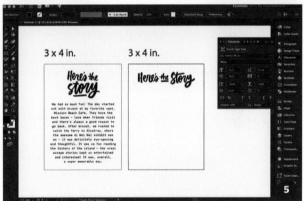

3 Save your scanned image or photo on your computer. Open your image in Adobe Photoshop to increase the contrast. Adjust brightness and contrast levels to make sure your lettering is clear.

4 Open your edited image in Adobe Illustrator. To turn your lettering into a vector file, open the image trace toolbar at Window > Image Trace. With your image selected, open the toolbar. Select the ignore white checkbox under Advanced, and click Trace. Click Expand under the top toolbar. If you are converting multiple pieces at the same time, right-click on the selection and select ungroup.

5 Create a 3" × 4" (7.5 × 10 cm) Artboard. Place your phrase in the card with enough space for journaling in the bottom. If you choose to add digital journaling, you can fill in the card in Adobe Illustrator. If you prefer to do handwritten journaling, leave it blank.

6 Add a ¼" (6 mm) border around the 3" × 4" (7.5 × 10 cm) card to serve as cutting lines. Create a new 8.5" × 11" (22 × 28 cm) Artboard, and put four copies of the 3" × 4" (7.5 × 10 cm) card.

7 Print, trim, and use the journaling cards in your scrapbooks and journals.

LETTERED PHOTO OVERLAYS

Digital lettering makes it easy to decorate your digital favorite (or most comment-worthy) photos with lettering and doodles.

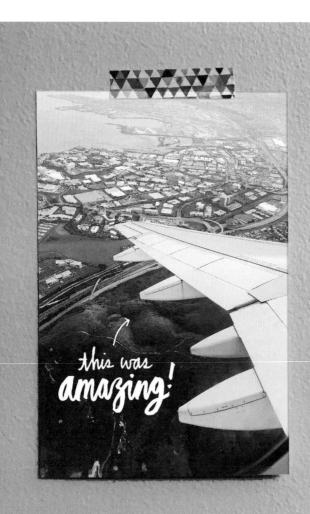
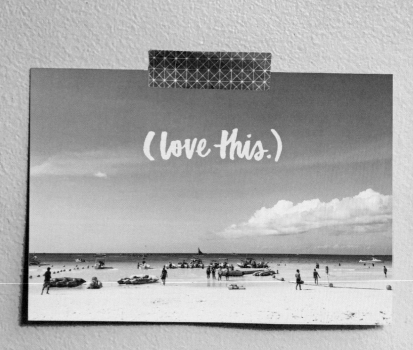

MATERIALS

- practice paper
- sign pens
- brush pens
- markers
- camera or scanner
- Adobe Illustrator
- Adobe Photoshop
- printer
- 8.5" × 11" (A4) card stock

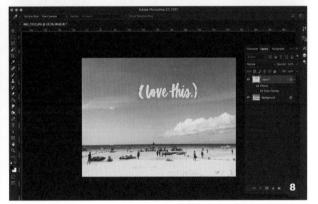

1 Letter out phrases and draw out doodles on practice paper with your brush or sign pens. For this project, we used phrases like "this was amazing" and "cool!" and drew out doodles like hearts, arrows, stars, and other geometric shapes.

2 Bring your lettering onto the computer via a photo or scan. If you are using a scanner, scan your sheet of practice paper. If you are using a camera, make sure that the photo you are taking of your practice paper is bright, straight, and in focus.

3 Save your scanned image or photo on your computer. Open your image in Adobe Photoshop to increase the contrast. Adjust brightness and contrast levels to make sure your lettering is clear.

4 In Adobe Photoshop, use the magic wand tool to select the white background on your image. Click Select > Similar to grab all of the white background, and then delete.

5 You will now have your doodles on a transparent background.

6 Choose a photo on your computer that you'd like to add doodles and phrases to. Open up the photo in Adobe Photoshop in a new document.

7 In your doodle file, select the element you want to add. Select it, and click Copy.

8 Paste it onto your photo and adjust the placement and size, as desired. To change the color, you can right-click on the doodle layer and select Blending Options > Color Overlay.

9 Once you've added all the phrases and doodles you wish, you can print out your photo or post it on social media!

Practice Sheets

Swirls and strokes

Using a brush marker: Follow along each brush stroke, as marked by the arrows.
Take note of the alternate thick and thin stroke variations as you work on your drills.

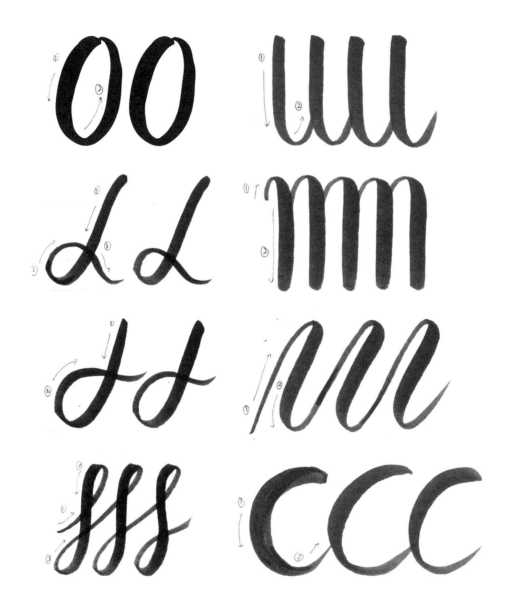

Using a pen: Follow and finish each line of handwriting strokes.

Alphabet Writing

Instructions: Trace along the corresponding alphabet styles
Recommended Tools: pencil, fineliner pen

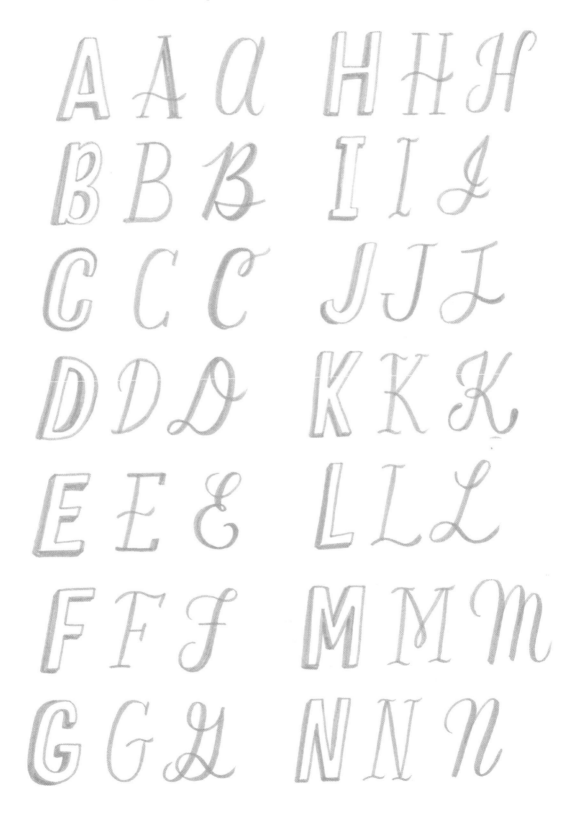

O O O U U U

P P P V V V

Q Q 2 W W W

R R R X X X

S S L Y Y Y

T T T Z Z Z

A Asia B Baxter C Carolina

Daughter Dover Everest E Essex

Finland Grant Harvey Heavenly

India J Jackson Kent Love London

yyyy major joining juice jug lllll lime elves

hhh ash hollow elbow hobby kkkkk knock elk

fff f frisk frog flask yolk lllll Talk loft

ddd dither dot ppp pox zephyr puzzle pencil

Copperplate Calligraphy

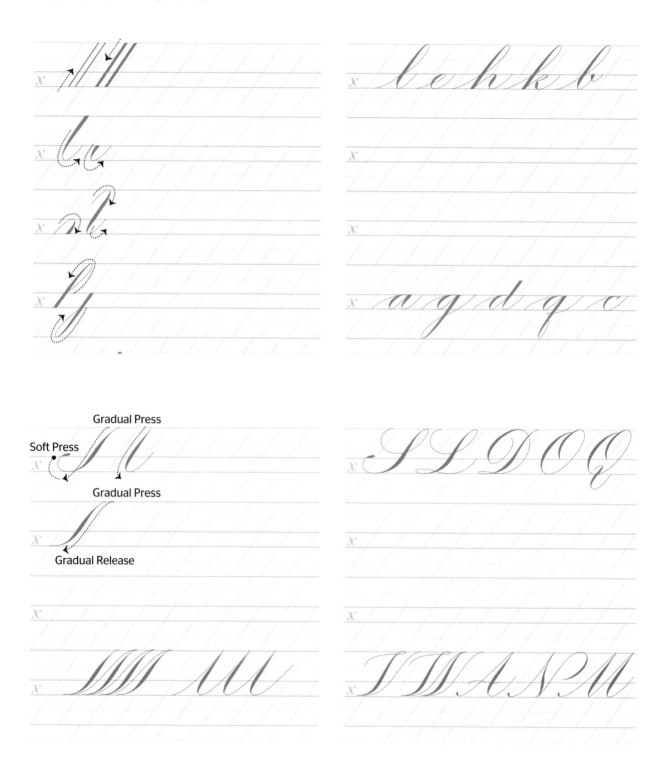

Soft Press
Gradual Press
Gradual Press
Gradual Release

x

x

x

x

x

x

x

x

Roman Calligraphy

A
B
C
D
E
F
G
H
I
J
K
L
M

N N N

O O O

P P P

Q Q Q

R R R

S S S

T T T

U U U

V V V

W W W

X X X

Y Y Y

Z Z Z

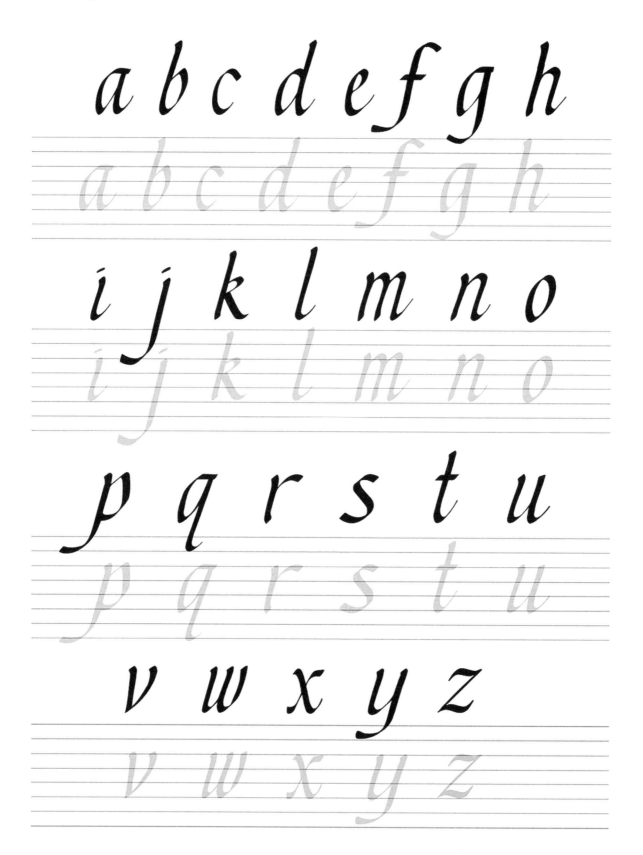

A B C D E F G

A B C D E F G

H I J K L M N

H I J K L M N

O P Q R S T

O P Q R S T

U V W X Y Z

U V W X Y Z

a b c d e f g h

i j k l m n o

p q r s t u

v w x y z

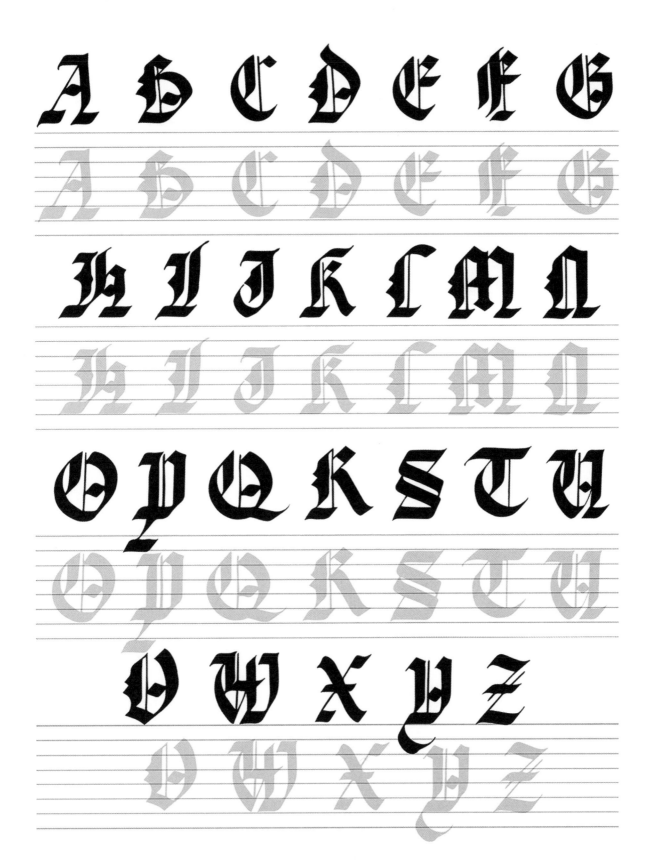

Word Drills

Instructions: Referencing from the set of A to Z letters on the left side, create a combination of font styles in serif, sans serif, and script forms.

Recommended Tools: pencil, fineliner pen

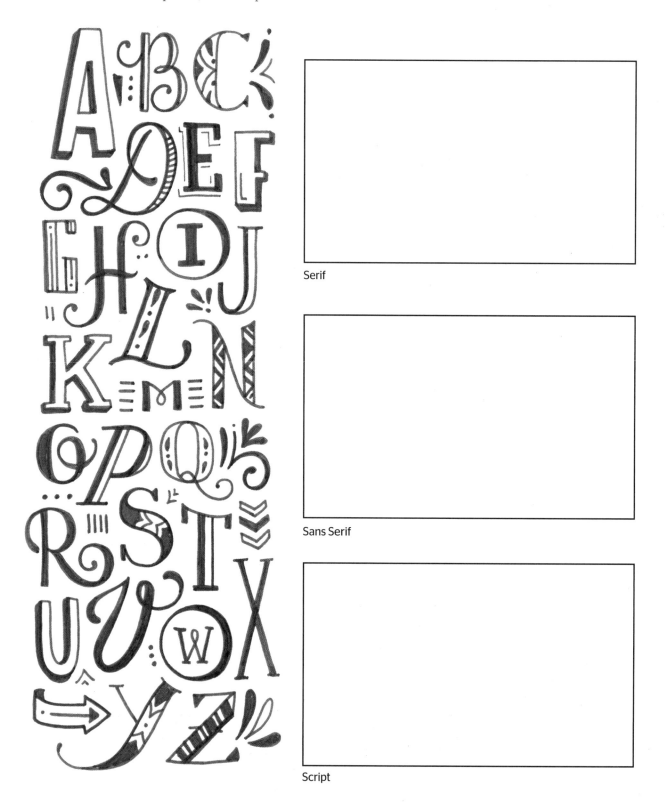

Serif

Sans Serif

Script

Instructions: Re-create the word "wonderful" in three styles.
Recommended Tools: pencil, fineliner pen

WONDERFUL

WONDERFUL

Wonderful

Decorative Lettering

Instructions: Recreate the decorative letters on the left side of each group, and redraw them.
Recommended Tools: pencil, fineliner pen

Serif Letters

Serif Drills

Instructions: Referencing the serif alphabet on the left, re-create your own serif style. Take note of the alternating thick and thin parts of each letterform.

Recommended Tools: thick and thin fineliner pens.

Aa

Bb

Cc

Dd

Ee

Ff

Gg

Hh

Ii

Jj

Kk

Ll

Mm

Nn

Oo _____ Pp _____

Qq _____ Rr _____

Ss _____ Tt _____

Uu _____ Vv _____

Ww _____ Xx _____

Yy _____ Zz _____

Sans Serif Letters

Instructions: Referencing the sans serif alphabets above the lines, re-create your own sans serif style.
Recommended Tool: thick fineliner pen or marker

abcdefg

hijklmn

opqrstu

vwxyz

Block Letter Drills

Instructions: Trace along the strokes of each letter and color in the shape using your marker.
Recommended Tools: thin fineliner pen and marker

Basic Script

Script Drills

Instructions: Referencing the sans serif alphabets above the lines, re-create your own script style. Take note of the alternating thick and thin strokes of each letterform.

Recommended Tool: brush tip pen

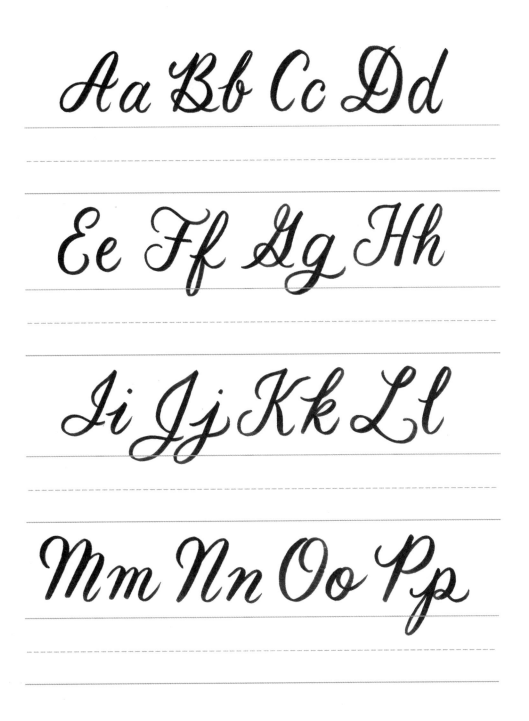

Qq Rr Ss

Tt Uu Vv Ww

Xx Yy Zz

Brush Letters Guide

Instructions: Follow along each letter and use these as starting points for your bounce lettering practice exercises.

Recommended Tool: brush tip pen

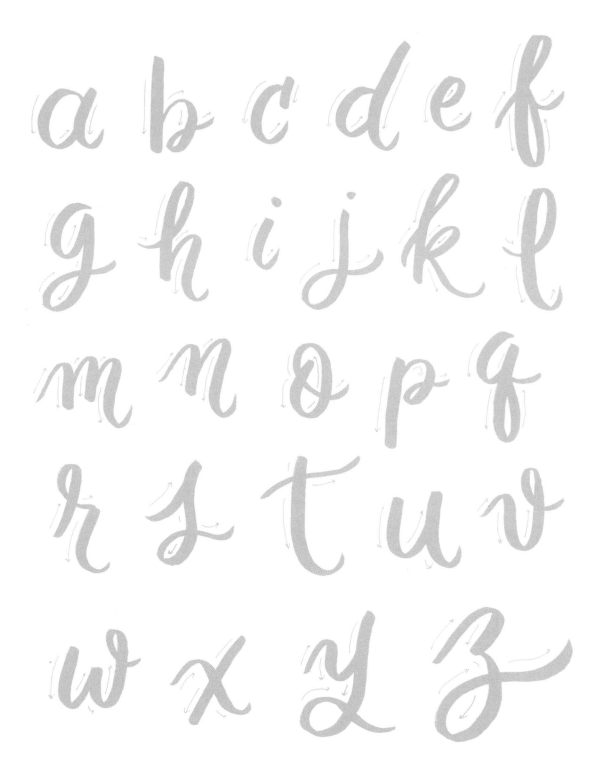

Bounce Layouts 1

Instructions: Trace along the first line and re-create your own on the second line of each quote. Take note of the bounces on each part of the word.

Recommended Tool: brush tip pen

Create today

El amor todo lo puede

Love will find a way.

La vita è un sogno

Life is a dream.

Bounce Layouts 2

Instructions: Trace along the left phrase and re-create your own on the right side of each quote. Take note of the spacing to allot room for each word to fit in the layout.

Recommended Tool: brush tip pen

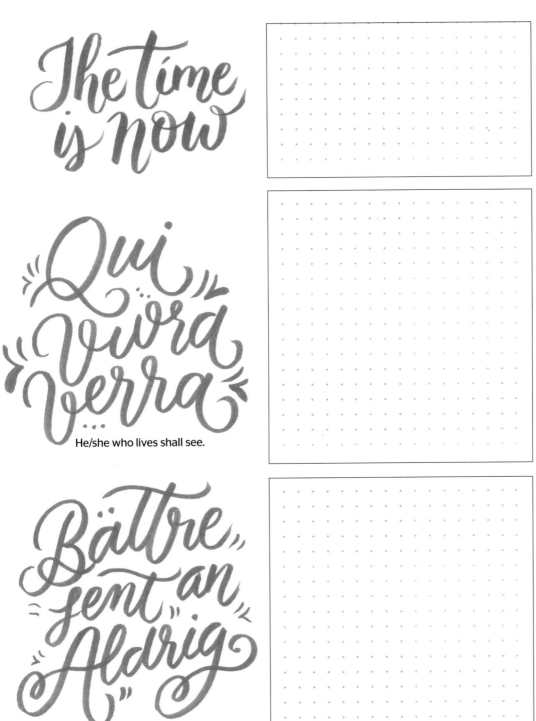

He/she who lives shall see.

Better late than never.

Layout Drills

Instructions: Word count (three words). Re-create the two thumbnails on the left using different font styles.
Recommended Tools: fineliner pen, marker, and brush tip pen

Live your life your own way, no matter what
others think of you.

SERIF + SANS SERIF + SCRIPT
No embellishments, bold letters

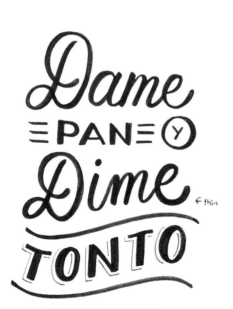

SCRIPT + SANS SERIF
Lined letterforms, wave on "tonto"

Instructions: Word count (five words). Re-create the two thumbnails on the left using different font styles.
Recommended Tools: fineliner pen, marker, and brush tip pen

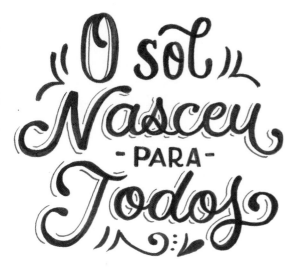

The sun rises for everyone.

SCRIPT + SANS SERIF
Loose scripts, height variation,
outlined scripts, flourishes

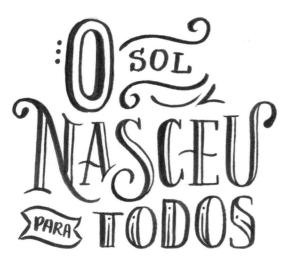

SERIF + SANS SERIF
Play on heights, dotted dividers,
uppercase letters, thick strokes

Layout Practice

Instructions: Compose layout styles using different font types and embellishments.
Recommended Tools: fineliner pen, marker, and brush tip pen

QUOTE IDEAS

Make today count
Progress not perfection
Enjoy the journey
Find joy in every day

Don't be afraid to try
Share your heart with your art
Never settle for second best
There's always room to grow

Layout Trace

Instructions: Follow along the layout of this quote. Observe proper spacing, kerning, and alignment of each letterform and word.
Recommended Tools: fineliner pen, marker, and brush tip pen

Love conquers all.

Resources

Websites

Amanda Arneill
www.amandaarneill.com

Artist & Craftsman Supply
www.artistcraftsman.com

Calligrafile
www.calligrafile.com

Calligraphy
www.calligraphy.org

Cult Pens
www.cultpens.com

Dick Blick Art Materials
www.dickblick.com

Happy Hands Project
www.happyhandsproject.com

J. Herbin
www.jherbin.com

Jet Pens
www.jetpens.com

John Neal Bookseller
www.johnnealbooks.com

Letter Lane
www.letterlanedesignstudio.com

Paper & Ink Arts
www.paperinkarts.com

Paper Source
www.paper-source.com

Pentalic
www.pentalic.com

Pilot Parallel Pens
www.pilotpen.com

Schminke
www.schmincke.de

Scribblers Calligraphy
www.scribblers.co.uk

Sip and Script
www.sipandscript.com

Society for Calligraphy
www.societyforcalligraphy.org

Society of Scribes
www.societyofscribes.org

Speedball Art Products
www.speedballart.com

Staedtler
www.staedtler.us/en/

The Washington Calligraphers Guild
www.calligraphersguild.org

Type Gang
www.typegang.com

Wet Paint, Inc.
www.wetpaintart.com

Books

The ABC's of Hand Lettering
by Abbey Sy
Summit Books, 2015

An Elegant Hand
by William E. Henning
edited by Paul Melzer
Oak Knoll Press, 2002, 1st edition

Fascinating Pen Flourishing
edited by E. A. Lupfer
Zaner-Bloser Company, 1951 edition

Hand Lettering A to Z
by Abbey Sy
Rockport Publishers, 2017

Learning to Write Spencerian Script
by Michael and Debra Sull
LDG Publishing, 1993

Mastering Copperplate Calligraphy
by Eleanor Winters
Dover Publications, 2000, Lettering,
Calligraphy, Typography edition

*New Spencerian Compendium
of Penmanship*
by P. R. Spencer's Sons, Ivison,
Blackeman and Company, 1879

Palmer's Penmanship Budget
by A. N. Palmer
The A. N. Palmer Company, 1919

*Tamblyn's Home Instructor
in Penmanship*
by F. W. Tamblyn
Ziller of Kansas City, 2001, 8th edition

The Universal Penman
engraved by George Bickham
Dover Publications, 1954

*The Zanerian Manual of
Alphabets and Engrossing*
Zaner-Bloser Company, 1918

Glossary

BLACKLETTER CALLIGRAPHY
Referred to as "gothic" or "Old English," involving a variety of calligraphic styles. It is dramatic with dark letterforms full of impact and contrast. Uniform, upright or vertical strokes and various built-up serifs usually characterize blackletter.

BROAD-EDGED PEN The main tool needed to write modern roman capitals. It makes variations in thickness of strokes as you position the pen on different angles.

CASUAL SCRIPT Emerged in the twentieth century, and has then been used for advertising and retro-style signages for diners and restaurants. The letters in this form are mostly written with a wet brush, making it looser than formal scripts.

COLORED INK Resembles most inks and is suitable for line art or calligraphy. Consistency may vary depending on the base of the inks (if it is made of acrylic, gouache or natural dye), so flow and quality of lines will vary too. Homemade acrylic-based colored ink will be more transparent and watercolor-like compared to ready-made ones.

COPPERPLATE Originally known as English Roundhand or Engrosser's Script. The pointed burin used for engraving the printing plates made letters rounded and slanted with contrast between thick and thin lines in mid-seventeenth century England. Scribes then began to carve and sharpen their pens, which is why the style is also referred to as "Engraver's Script." For almost four centuries of use, there have been a few changes in its execution, but the basic aesthetic is largely the same.

FINELINER PEN Also known as a technical pen, it is the most common type of pen used for decorative lettering. This pen is best used on paper, and usually comes in a round tip. Most fineliner pens come in varying widths—from 0.05 to 1.0 mm, depending on which purpose it is used for. A key feature of fineliner pens is that it's meant for drawing, not writing.

FLAT-TIP DIP PENS Commonly used and are great for doing black letter, Italic and other hands. Although the parallel pen is available, there are still those of us that favor this tool. Flat-tip dip pens are of two parts—the nib and the holder. There are various types of nibs that you can use that come in different cuts and sizes and are considered flat tip. Expect though that the nibs used for this pen have a very low flex level, thus stiffer nibs. This can be a good thing, especially for beginners as your muscle memory for writing is still adjusting.

FLOURISHES Adds character to your hand lettering layouts and creates a more cohesive look to your design. It is easiest to add to script-style fonts as they are very fluid and can connect well. Flourishes are often also used in border work and headings.

FORMAL SCRIPT Originated from calligraphy in the seventeenth to eighteenth century. The strokes are usually at a certain angle to the right, and all letterforms are connected in each word. The letters in this form are written with a quill or metal nib, making it able to create both thin and thick strokes. This script style is naturally more elegant and traditional and is commonly used for diplomas and invitations.

FOUNTAIN PEN A more convenient alternative to dip pens. Fountain pens store ink in cartridges that are easily refillable. A big difference between a fountain pen and a dip pen is its flexibility. Fountain pen nibs tend to be less flexible, therefore resulting in less stroke contrast. Not all fountain pens are designed to flex, so be sure to check the pen before applying pressure.

INKS Come in a variety of colors, black being the most commonly used.
They are also made of different transparencies, and most inks come off as opaque. Depending on preferred consistency, inks can be thick or thin and can have different effects on paper with these changes. You can choose between dye-based, India, sumi, and white ink.

ITALIC CALLIGRAPHY Also referred to as Chancery Italic or "cursive." Most beginners start here to learn calligraphy. The mesmerizing and elegant letterform of italic makes it one of the best styles in writing. Although

Glossary

a family of scripts, italic is usually characterized by forward slopes—slanting to the right, springing arches, and dynamic style.

LETTERFORMS The graphic form of a letter of the alphabet, either as written or in a particular type font.

MAJUSCULES The writing of the capital letters. It depends highly on the execution of the capital stem, also called a "compound curve."

METALLIC WATERCOLORS Used to create sparkling calligraphy. The watercolors are made with a natural shimmering mineral, making it instantly sparkly when applied on paper.

MINISCULES The writing of small letters. Unlike normal handwriting, each pen movement is controlled and precise.

NIB HOLDER Come in both straight and oblique. Using the straight nib holder gives a modern and straight effect to your work, because unless you deliberately angle your paper, your writing will be upright. It is generally easy to control and is fit for beginners as the orientation is similar to a pencil or pen. Using the oblique nib holder gives an automatic slanted effect to your letters and flourishes, making it great for practicing formal styles such as Spencerian and Copperplate calligraphy.

NIBS Come in both pointed and italic or broad edged. Pointed nibs are flexible and are used for most script calligraphy styles, as these have the versatility to produce thick and thin strokes. Its two tines have the ability to split and produce wide lines. Italic or broad-edged nibs are flat and not designed to flex. These are used for italic, black letter, and gothic letterforms. This nib type is used to create consistent and regular strokes for uniformity. It is made of a blunt edge and strokes come out thin or bold on the surface.

OFFHAND FLOURISHING Similar to ornamental penmanship such that it is both a showcase of skill and creativity. With the rise of the elaborate scripts, scribes began extending flourishes to create works of art through the execution of curvatures and ovals, the contrast and placement of heavy strokes and fine lines, and an overall delicate movement. The primary designs were of birds, plumes, cartouches, scrolls and various foliage.

POINTED PEN Used with Copperplate, Spencerian, and offhand flourishing and opposite of the broad-edged pen.

PARALLEL PEN A modern tool produced by Pilot pens. It is an excellent writing tool to start with for Blackletter style writing. This is a broad-edged pen, that makes variations in thickness of strokes as you position the pen on different angles.

ROMAN CALLIGRAPHY Derived from ancient Roman letters that are seen inscribed on monuments. Compared to its traditional counterpart, Modern roman capitals are modified for writing using pens instead of using brushes.

SPENCERIAN PENMANSHIP Named after Platt Rogers Spencer (1800–1864), the man who developed this beautiful, flowing style of penmanship. The script is generally without shading, with swells only prominent in the capital letters. Spencer's writing system encouraged freedom of movement. When it was established, it became a force in education and promotion of literacy as well as in business. The acceptance and growth of this new system also marked the start of America's "golden age of penmanship" (1850-1925).

WEIGHT LINES Adding this in a body of text implies that it has a distinct message that needs to be highlighted. In the same way, applying this technique to hand lettering is an indicator of importance for a specific bold set of words or sentences.

Contributors

Fozzy Castro-Dayrit
Calligrapher

Fozzy is calligrapher from Manila, Philippines. Before being the "CalligraMama" for being one of the kickstarters of the calligraphy addiction in the country, she was an account director at Ace Saatchi and Saatchi Advertising. She is a mom of two, an addict to pens and ink, and a slave to bacon and coffee. She is one of the pioneering instructors in the Modern Calligraphy Summit, the first completely online convention on calligraphy. Her writing has been featured in premiere wedding blogs like Style Me Pretty and Magnolia Rouge, and in the book *Hand Lettering for Everyone* by Cristina Vanko. She is currently obsessed with studying Spencerian penmanship under the guidance of Master Penman Michael Sull.

Instagram: @thefozzybook

AJ Tabino
Calligrapher / Calligraffiti
Ambassador

AJ is a Cebu, Philippines–based calligraphy artist who started in 2015. She is a nonconformist whose works cultivate a modern approach on various calligraphy hands. Handpicked by graffiti legend and founder of the Calligraffiti movement, Niels "Shoe" Meulman, she became one of the fifty International Calligraffiti Ambassadors in November 2015. Her work has been featured in different exhibits, publications, and local TV shows. In 2016 alone, she served as a guest speaker for USC: TEDx Women, USC A3: Advertising Congress, and Josenian Diplomats: Art for Peace. To this day, she is still working with different brands and companies serving as a freelance calligraphy artist.

Instagram: @ajtabino

Jelvin Base

Designer / Developer

Jelvin is a web developer and creative based in Manila. He creates user interface designs and does front-end coding during the day while moonlighting as a freelance designer specializing in design, custom lettering, and typography. As a person who's constantly looking at screens all day, Jelvin finds comfort in doing creative activities like lettering and graphic design, which lead him to landing different jobs on the side.

Jelvin is a firm believer in having a solid foundation in everything in our lives, whether it is lettering, illustration, or even tackling a relationship.

Website: http://jelv.in
Instagram: @jelvin
Behance: http://behance.net/jelvin
Dribble: https://dribbble.com/jelvin

Geli Balcruz

Calligrapher / Creative Entrepreneur

Geli has always been a lover of all things creative, from writing to drawing to photography to painting to anything that sets her creative soul on fire.

After attending a calligraphy class taught by Fozzy Castro-Dayrit, she fell in love with making letters dance and has not stopped since. Specializing in modern calligraphy, she manages freelance work with teaching calligraphy classes, holding demos, workshops, participating in exhibits, murals, and partnering with both local and international companies.

As a psychology graduate, she is an advocate of art as a means of self-expression to improve one's holistic well being. She creates merchandise for her brand, Pluma, which was created to transform her heartworks into everyday essentials.

Website: gelibalcruz.com
Instagram: @gelibalcruz

Risa Rodil
Designer / Illustrator / Letterer

Risa is a designer, illustrator, letterer, and a pop culture lover from Manila, Philippines. She's a creative spirit who pulls inspiration from books, travel, TV, and film. Upon discovering her love for art at age 14, she found herself bouncing from one creative field to the next—trying out photography, video production, and web design, until she finally landed on illustration and lettering. It took her a couple more years to find her own art style that has now attracted clients around the world; a vibrant mixture of striking colors with a touch of whimsy and modern retro. On her days off, she likes to visit new cities, read books, and go full nerd by binge-watching television shows.

Website: www.risarodil.com
Instagram and Twitter: @risarodil
Facebook: facebook.com/risarodil

Christine Herrin
Designer / Letterer

Christine is a graphic designer and hand letterer from Manila, Philippines. She has a background in publishing design and loves paper, documenting, and all things analog. She was named one of Adobe's Creative Residents in 2016, where she started Everyday Explorers Co., a line of paper goods centered around traveling and creative documentation. When she's not designing journals or clear stamps for her paper line, you can find her exploring her favorite cities by foot and being constantly inspired by new places and experiences. She currently lives in San Francisco, California.

Website: christineherrin.com (personal); everydayexplorers.co (shop)
Instagram: @christine.herrin

Acknowledgments

Working on this book has been such a fun and fulfilling experience. I have always loved writing about hand lettering, and this opportunity has given me another avenue to do so in the best way possible. I'd like to thank my editor, **Joy Aquilino**, for giving me the opportunity to write and illustrate this book, as well as providing support and guidance throughout the process of book making; and my art director **Marissa Gambrione**, for helping guide the creative direction of the book that you now have in your hands. It is always amazing to get to work with people who understand your vision and turn it into reality.

Moreover, thank you for the **Creative Publishing international team** for this opportunity. I have learned so much and gained new knowledge in my chosen field, and I hope to further share what I know to aspiring artists and makers.

I'd also like to thank my team in the Philippines—my manager **Tricie**, assistants **Stacey**, **Louise**, **Alex**, and **Jean** for the moral support and help. Special thanks to Stacey for all the help she has provided as my research assistant.

I'm extending my infinite thanks, as well, to the wonderful contributors who shared their work in this book—**Fozzy**, **Geli**, **AJ,** and **Jelvin** for calligraphy, and **Christine** and **Risa** for digital lettering. Learning more about hand lettering and calligraphy through the words and ideas of other artists and perspectives has paved the way for this book to become even more informative for artists and hobbyists.

Lastly, I'd like to thank **my readers** who have been supporting my work since day one. Never did I imagine being able to write books as part of my way to share my creativity with the world. Thank you for reading; and may you always be creating.

About the Author

Abbey Sy
Illustrator / Hand-Letterer / Author / Teacher

Abbey Sy is an artist and author from Manila, Philippines. Best known for her hand-lettering work and travel illustrations, she has worked with a wide range of clients from various industries. She has written and illustrated best-selling books on hand lettering and journaling, including *Hand Lettering A to Z* (Rockport Publishers 2017) and her art has been recognized on both local and international websites and publications such as *BuzzFeed*, *DesignTaxi*, and *IdN magazine*, to name a few.

She currently works as a creative entrepreneur—writing and illustrating books, teaching art classes on weekends, and producing her own line of products, in the hopes of further fulfilling her artistic dreams and fueling her passion for both art and travel.

View Abbey's work at
Website: abbey-sy.com
Facebook: fb.com/artbyabbeysy
Twitter & Instagram @abbeysy

Index